To Edith,
with best wishes
and Happy Birthday!

Simon Jenkins —
August 2006.

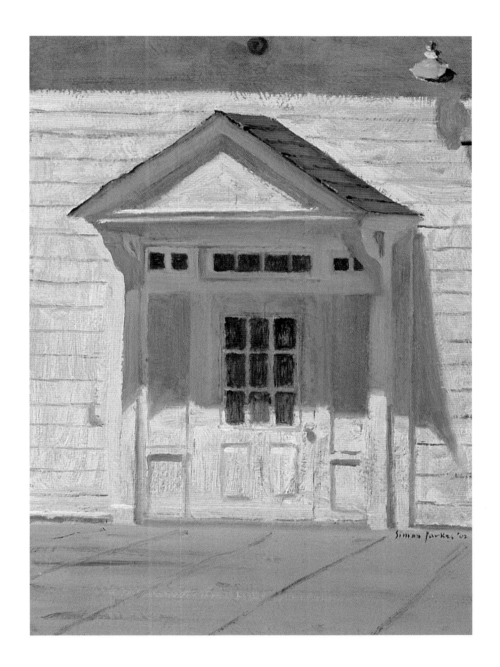

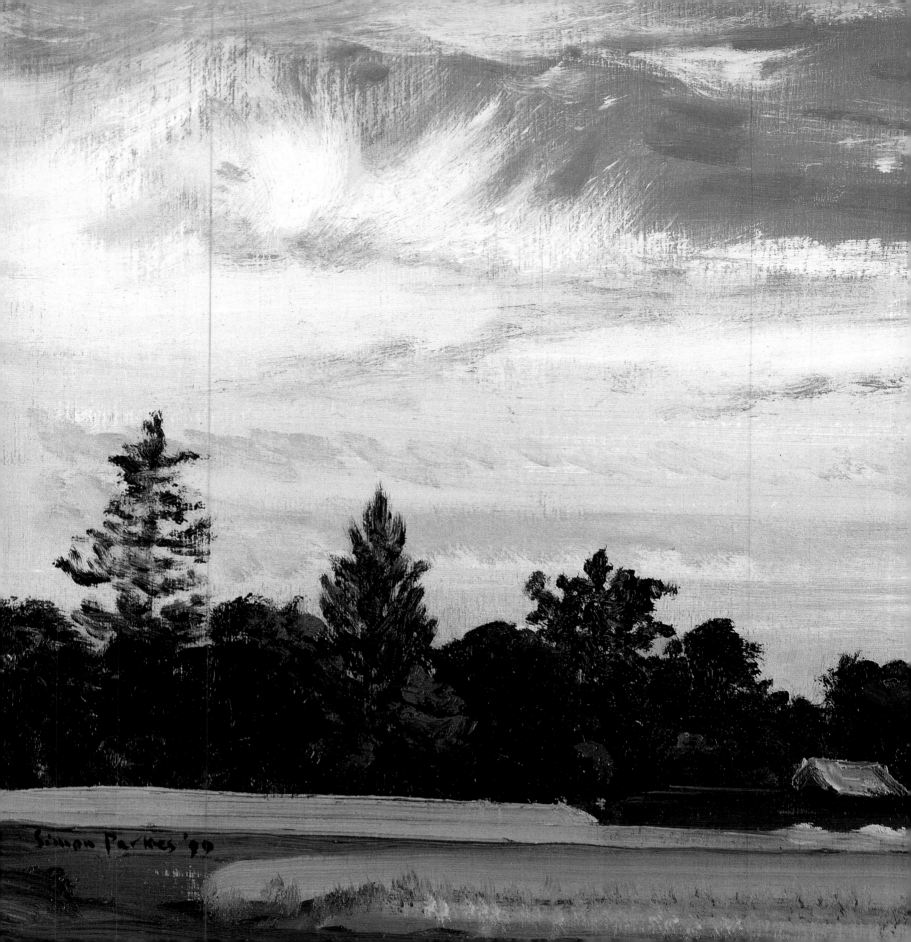

SIMON PARKES

Summer Places

Eastern Long Island and New England

TEXT BY
ANGUS WILKIE

A MARK MAGOWAN BOOK

THE VENDOME PRESS

New York

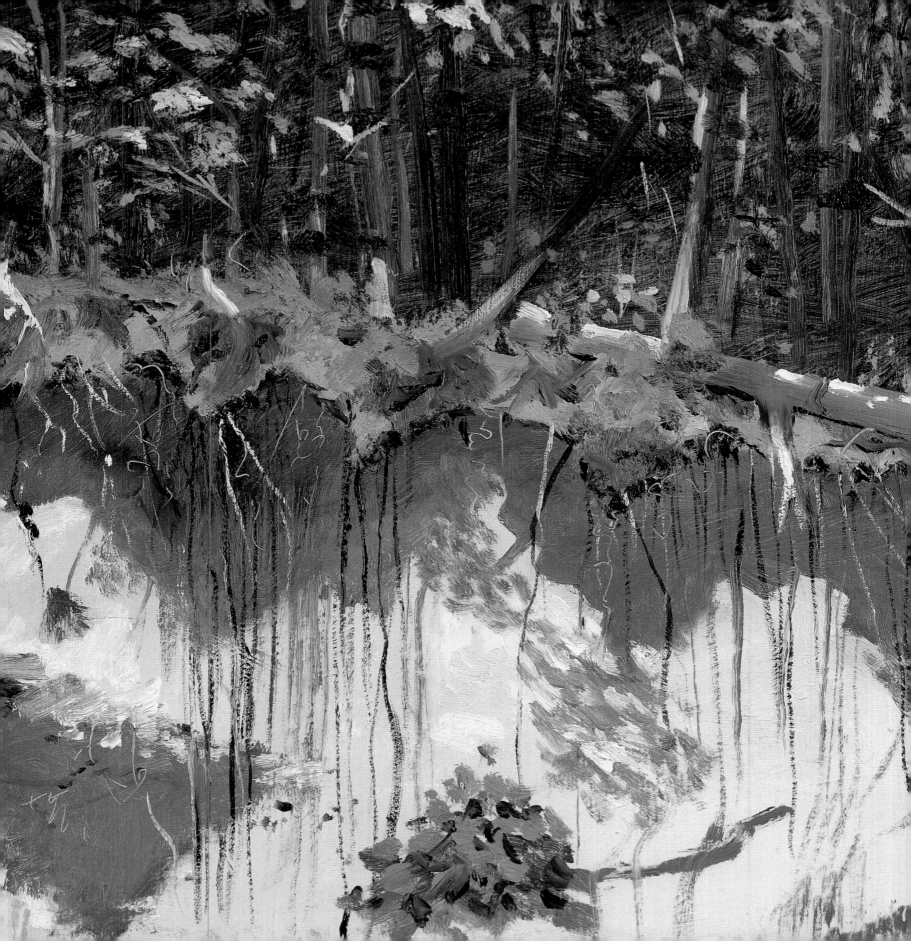

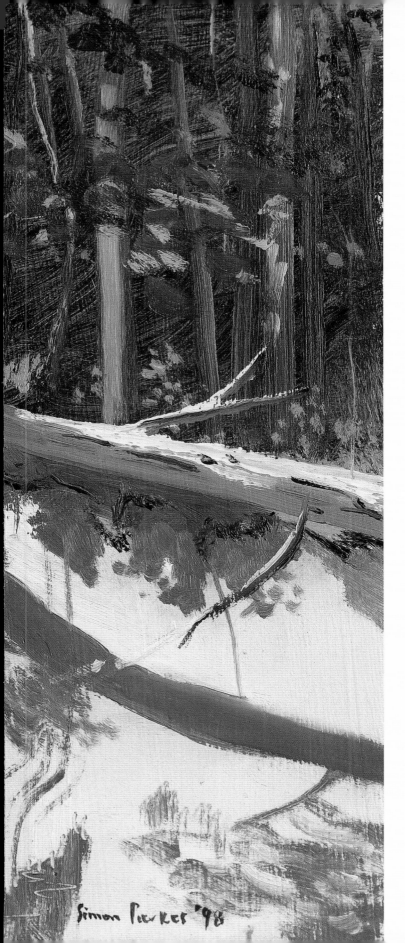

Simon Parkes '98

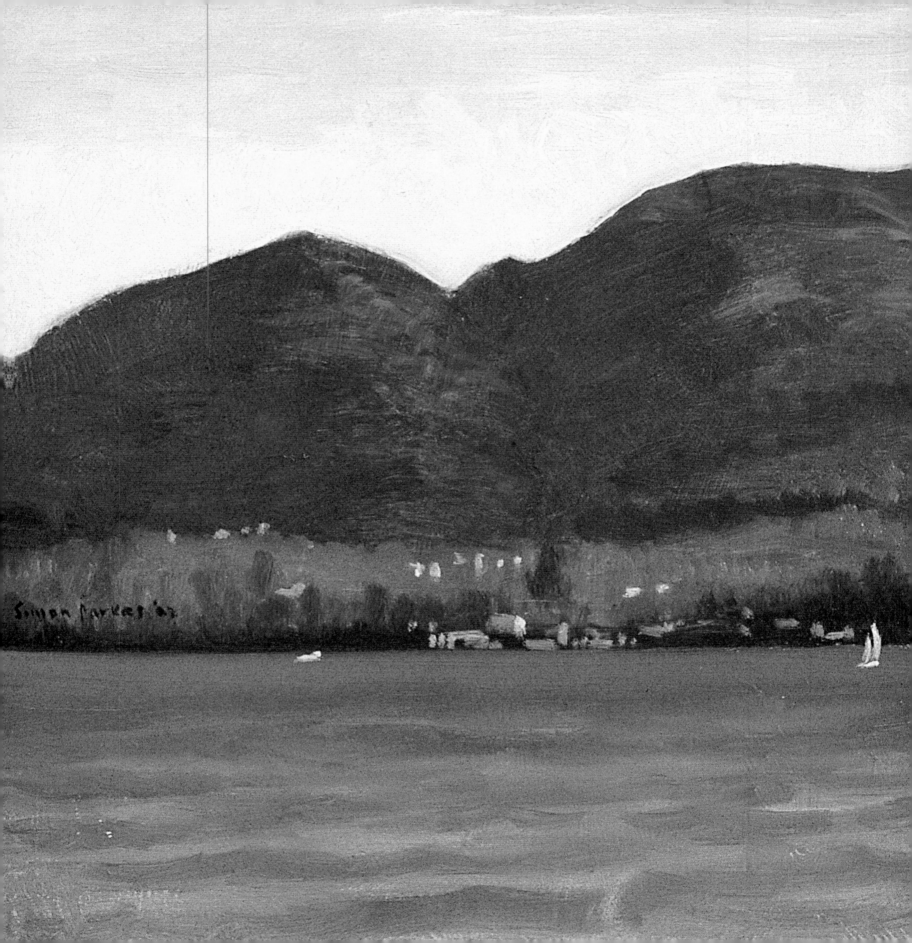

Introduction

To most city dwellers, a summer retreat is vividly charged with promise. Breezy shores and mountain lakes, advantageous sites for outwitting seasonal heat, are healthy antidotes to concrete and gridlock. While urban life presents the competitive challenges of an ever changing present, classic American summers in the countryside invariably are entwined with happy memories of childhood, family affection, and a salty taste of adventure. As extended relations convene, families balloon under the shingled roof of a seaside cottage, rambling and gracious, or the cozy protection of an Adirondack lodge. These places have a comforting sameness to them; the hope is that they change little from year to year. The notion of time standing still induces a shiver of contentment as lazy afternoons and soporific nights under the stars unravel with a dreamy sense of abandon. Summer tickles with a vision of plenty, a therapeutic life current handed down for generations.

In the nineteenth century, improved transportation increased easy access to faraway encampments in the woods and along the shore. Summer folk established settlements along the Hudson and Connecticut Rivers, as well as the eastern seaboard from New Jersey to Maine. Water travel by steamship and ferry was the least expensive means to escape a sweltering metropolis. Once railroads penetrated dense forests and highways paved the way for automobiles to traverse shaggy green valleys, more and more inland watering holes, far from any navigable

Mount Desert from Hancock Point

7

coastline, were built near freshwater ponds tucked in verdant hills.

Artists were among the first to discover the natural splendors of the northeast and initiate a rhythm of an annual visiting culture. Lured by pine forests, rock formations, and New England's native tranquillity, they arrived by schooner, steamboat, and stagecoach to record picturesque views. The Hudson River School of American painters represented the artistic vanguard. Its members, including Thomas Cole and Frederic Edwin Church, focused their initial efforts along the wide riverbanks of the Hudson Valley and eventually explored other destinations in search of scenic beauty. They enjoyed a primitive existence, ruggedly camping and boarding in bohemian surroundings as they sketched untrammeled sites. Undulating meadows, wispy sand dunes, and wrinkled granite parapets, abrupt and bare, were their subject matter. They sought refuge in inaccessible locations from the windswept cliffs of Long Island's Montauk Point to Appledore Island, one of the Isles of Shoals off the coast of New Hampshire and Maine, where poet and arts enthusiast Celia Thaxter ran a famous summer hotel and cultural meeting place for writers, musicians, and painters.[1]

Direct observation of nature became the private obsession of mid-nineteenth-century American artists whose output spread the word on the drama of New England's wilderness. Other early pioneers were John Frederick Kensett and Sanford Robinson Gifford. Amateur draftsmen with a similar calling followed in their footsteps. The seemingly boundless scenery, from snug harbors and glinting bays to irregular bluffs and inky depths, became a natural magnet for them. Over time, these pivotal renderings and excited talk about newly discovered locations brought city folk face to face with the outdoors. Inspired by breathtaking vistas and the notion of something good for the soul, clergymen, professors, scientists, naturalists, yachtsmen, and like-minded explorers who could spare the time followed in a summer migration pattern to the peninsulas of Long Island, Cape Cod, and Maine.

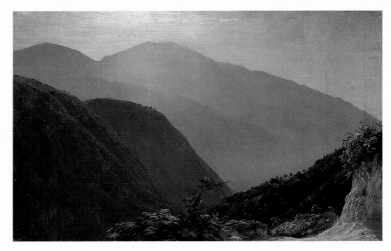

Frederic Edwin Church, Blue Mountains, Jamaica, *1865. Cooper-Hewitt, National Design Museum, Smithsonian Institution, New York.*

It was not long before masses of affluent urbanites and their extended families descended upon unsuspecting rural New England habitats.

The spectacle of wealthy, well-dressed Victorians gazing upon barren headlands for the first time made for a curious turning point. Before the influx of a metropolitan elite, a small population of farmers and seaworthy locals had settled the pristine coastal landscape; however, they built their houses inland. Living beside the ocean was anathema to them and a stony shorefront was considered useful for animal pasture and little else. Turn-of-the-century arrivals from nearby cities may have seemed disoriented at first, but they wasted little time in transforming the rocky shoreline. They built sprawling shingle-style cottages that boasted capacious rooms, comfortable amenities, and a warren of servants' quarters. A sport of comparing water views ensued as a leisurely pursuit among status-minded parvenus. Unlike early settlers, who wrested a living from the open water as opposed to doting upon it, gentrified tourists inhaled the sea for all its aesthetic and soothing possibilities while taming the unruliness of coastal scrub and mosquito bogs. The Gilded Age development of fortresslike mansions, boardinghouses, hotels, and spas followed. As summer colonies full of creature comforts encroached upon the bucolic simplicity of the land, the seaside interests of visiting artists that had once appeared peculiar seemed suddenly prophetic.

Continuing a romantic link to the nineteenth-century tradition of *plein air* painting, contemporary artist Simon Parkes masterfully portrays his favorite New England summer destinations with an organic rhythm that reveals the unspoiled essence of landscape. A crooked path rising through brambles, mottled shadows that meander across a derelict barn, a tufted mound of sea grass clinging to the lip of a sand dune are the funky and deceptively simple views he prefers to paint. Depicting, in his own words, "a property that grows the way it wants to grow," or "an unsettled sky that evokes a particular feeling," Parkes deftly captures material bits of explosive scenery in seemingly effortless ways. The

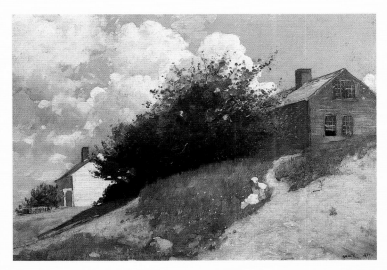

Winslow Homer, Houses on a Hill, *1879. Collection of Marie and Hugh Halff.*

artist's inner impulse is to record motion, as if light and nature were capable of breathing. The exciting immediacy and delicate tonality of his work deliver a sense of time and place that captures environmental secrets as he sees them. In addition to recording physical phenomena, he is able to articulate intangible subtleties of the natural world. Atmospheric conditions—flickers of heat, wind, and light—are rendered with dazzling daubs of color that expose the act of sketching and spark his paintings to life.

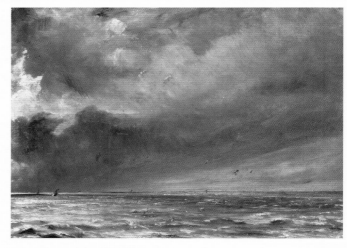

John Constable, The Sea Near Brighton, *1826. Tate Britain, London.*

It has been said of the great English landscape painter John Constable (1776–1837), who devoted a curiously scientific attention to sketching in oil meteorological studies of turbulent skies (a practice he called "skying"), that he was less an interpreter of nature than a part of it.[2] Obsession with volatile, swirling cloud formations is a tangible component of Constable's "skying" oeuvre. The artist painted close to one hundred cloud studies during a period of concentrated work at Hampstead Heath circa 1820–21, dating his observations of combustible configurations and recording the precise hour of scrutiny as he sketched.[3] The pictorial syntax of these innovative pictures set the stage for a new artistic preoccupation with weather portents. In capturing on paper a fleeting cloud pattern, an elusive splinter of light, or an evaporating mist, Constable's sky paintings evoke an emotional tenor that epitomizes the *plein air* genre.[4]

The urgent grasp of an evanescent moment is key to the mood of a successful picture. As a sky metamorphoses before their eyes, *plein air* artists like Constable are possessed by a fervor and affection for untold variables. Parkes calls the act "a hurried deal with nature." It is no surprise that the effort is accompanied by sudden bursts of energy. Eighteenth-century artists' journals state that a picture painted in the open air was typically accomplished in a mere two hours[5]; at times of dawn or dusk, changeable light engendered a more frenzied transaction with the elements. Then as now, moments are precious and not to be wasted on narrative detail; the goal is to paint actual places at specific times of day as if the scene has landed on the canvas in one great gust of wind.

In the seventeenth century, direct examination of nature was, however, considered an inspirational means to a more finished product. Large landscape views from this era were typically executed indoors within the confines of artists' studios. Around 1650, the invention of the painter's traveling box[6] increased the popularity of swift sketching, particularly among landscape painters working in the rich artistic environs of Naples and Rome. Small in scale and portable, the folding boxes contained accoutrements such as paints, palette knives, brushes, bottles, rags, solvents, and sheets of paper. Their covers were often designed to double as an easel. Constable, for instance, fixed his small sheets within the cover of a paint box balanced on his knees.[7] Outdoor views were typically executed on paper (which dried quickly), cardboard, or wood panel. Rarely framed and intended for private study, these impromptu renderings were pinned to studio walls for inspiration. At the time, connoisseurs did not particularly acknowledge them for their aesthetic or commercial qualities.[8]

By the end of the eighteenth century, a school of *plein air* painters had gathered strength in and around Rome. Visits to Italy played a vital role in the training of young European artists, and the ancient city was a cosmopolitan and lively place to be, attracting an energetic band of Frenchmen, Englishmen, Danes, Belgians, Swedes, Germans, Swiss, and Norwegians. They commingled freely and explored architectural ruins as well as the stony precipices of surrounding sites. A transient sense of light enlivened the brush as it caressed the nips and tucks of nature. Embracing memorable views like friendly companions, traveling artists allowed their emotions to stream forth as they sketched familiar locations. Working feverishly, with loose strokes and thick smears of paint, they attempted to highlight the momentary effect of a distant church dome glimmering after a bout of rain, a creamy stucco hill town awash in a beam of chalky sunlight, or an amber sun setting on a tumbledown aqueduct.

Working as early as the 1770s, a French artist, Pierre-Henri de Valenciennes, Belgian Simon Denis, and Welshman Thomas Jones displayed noteworthy artistic

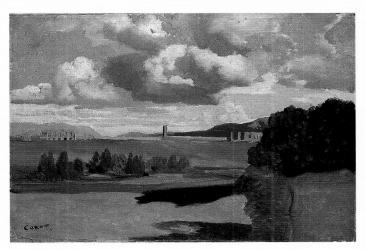

Jean-Baptiste-Camille Corot, The Roman Campagna, with the Claudian Aqueduct, *1826. The National Gallery, London.*

originality while recording their spontaneous observations of Rome and its blissful surroundings. Their verve for ephemeral handling led the way for other European artists excited by the episodic virtues of *plein air* study. Jean-Baptiste-Camille Corot (1796–1875) arrived in the city for the first time in the fall of 1825, aged twenty-nine, and chose a popular hangout, the Caffé Greco, as his postal address.[9] Corot worked in and around Rome for several years, documenting the landscape with taut compositions and exacting visual records. His romantic passion for Italy's grand natural aspects earned him an instant and preeminent reputation as a master of the *plein air* genre.

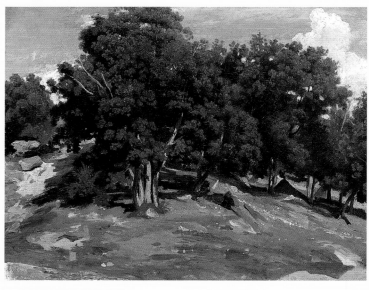

Jean-Baptiste-Camille Corot, Fontainebleau: Oak Trees at Bas-Bréau, *1833. The Metropolitan Museum of Art, New York.*

　　Curiously, however, the merits of these typical oil sketches again remained largely unnoticed by a critical mass until the second half of the twentieth century. The artistic output was a private pursuit never intended for commercial sale. Tacked on studio walls for reference, or tucked away in portfolios for future use, they were largely unsigned and thus consigned to anonymity following their dispersal in artists' estate sales. The late John Gere, keeper of prints and drawings at the British Museum, noted, "One practical reason for the neglect of the oil-sketch was the problem of classification . . . a further difficulty was the problem of attribution."[10] In the 1950s Gere and his wife, Charlotte, began to collect these small-scale oil landscapes and, by the late 1970s, he and his colleagues in London organized an exhibition at the British Museum, *French Landscape Drawings and Sketches of the Eighteenth Century.* This groundbreaking effort rescued the field from critical limbo and was followed three years later by *Painting from Nature,* a show at the Royal Academy in London. In the past twenty-five years, these brilliant landscape views have become highly esteemed and collecting them is now a competitive activity. As recently as 1996–97, an immensely rewarding traveling show titled *In the Light of Italy: Corot and Early Open-Air Painting* rekindled the magic of Italian oil sketches on the walls of the Brooklyn Museum, the National Gallery of Art in Washington, D.C., and the St. Louis Art Museum.

Coincidentally, Parkes's infatuation with sketching in oil matured at a similar moment in time. Throughout his career as a restorer, Parkes estimates he has worked on several dozen oil sketches by Corot. Learning as if by osmosis, the artist cites a growing awareness of Corot's freshness and treatment of the genre as a profoundly formative influence that shaped his own future as a painter.

Born in England in 1954, Simon Parkes was partial as a youth to the rough knolls of his native Berkshire. Roaming rugged fields instilled in him a lasting affinity for endless stretches of open space. His roots were earthbound and landlocked while the walls of his childhood home were tantalizingly hung with a taste for natural realism. "Oil paintings by Benjamin Williams Leader," he says, "an English landscape artist who was my father's uncle, and prints by Corot informed my eye early on." At the age of seventeen, Parkes moved to London, where he apprenticed for several years in Chelsea with two painting restorers. The proficient trainee left England, aged twenty-four, and moved to New York City, where he worked briefly for an auction house, the William Doyle Gallery, in the Paintings Department. In 1981 he became his own boss, founding Simon Parkes Art Conservation, Inc., on Manhattan's Upper East Side.

Cumulative art historical knowledge and a taste for a certain type of picture developed over the next decade. It seems entirely possible that Parkes was born to a landscape theme; however, he developed his talent with the brush and palette through his restoration work and matured as a *plein air* artist relatively late in life. He is quick to note that he painted his first landscape only in the 1990s, when he was in his early forties. "I was aware of artistic impulses, and I restored other people's work, for as long as I can remember. I certainly painted in my head years before producing anything original," he notes.

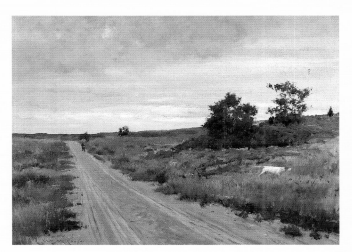

William Merritt Chase, Hunter with His Pointer in a Long Island Landscape, *1897. Courtesy Berry-Hill Galleries, New York.*

His budding talent emerged while he was spending time with his wife and two sons at his in-laws' 1920s silver-gray, shingle-clad house comfortably nestled behind a protective dune in East Hampton on Long Island. As he explored surrounding vistas, from the South Fork's tilled potato rows along rural Route 114 to the

weather-beaten bluffs of Montauk Point, the fertile farmland and countryside reminded him of home. However, Parkes was forced to grapple with the unfamiliar prospect of a seemingly endless and mercurial sea. His encounter with a boundless horizon, one that fused earth, sky, and water with a more complex sense of light, expanded his universe dramatically. New variables are often the challenging ingredients that tweak an artist's imagination. "I rarely saw the Atlantic before coming to America," Parkes confides, "and I have such a feeble imagination I never could have made it up."

Rising at dawn to the rumble of waves, Parkes sets out early to paint eastern Long Island's morning light. He packs his car with easel, canvas, panels, paints, brushes, and an expedition knapsack containing such vital necessities as coffee thermos, sunscreen, and bug repellent. He often drives without a specific site in mind, allowing his instincts, or temperamental skies, to fire his imagination. A favorite destination is Sammy's Beach, a landlocked inlet with rambling dunes along Gardiner's Bay near Three Mile Harbor. Parkes divides an arid and unassuming view (p. 40) into two registers of earth and sky. Clumps of frizzled grass seem to crackle under a hazy swelter of languid cloud. The canvas is seared with oppressive heat, an expressive by-product of the painter's good color values and accurate tonal relations rendered in the pale nuances of unpunished sand. The focus is no more than the rhythm and shape of shadows at play. One could imagine being the first person to tread here or the only person ever to see the light scrape the land just so. "The simplicity of this painting just gives me the right feeling," says Parkes. "It's exactly what I'm about."

This lonely stretch of beach is an opportune position to which the artist returns repeatedly. As a rule, Parkes eschews broad panoramas in favor of a humble focal point. A spine of weeds delineating a path is ample subject matter. In the medium of oil, the exercise of capturing changeable light as it affects a familiar stretch of unpretentious ground at different times of day is critical to a sense of inspection. Vigorous contrasts of light and shade, the effects of natural chiaroscuro, become the theme as much as the topography itself. At times, Parkes tilts his canvas to encounter a skyward view, painting quickly to capture light in a different guise. He balances the foreboding omen of sullen storm heads by anchoring the foreground with a solid strip of soil at the bottom of the sheet. (pp. 80–81).

"One can paint in the same spot many times, morning and evening, and the picture will look completely different as long as you are faithful to what you see," he says. "I do not make it up, nor do I edit out. Alone with the ticks in the sun or the rain, I feel as if the world freezes for me in an instant."

Changes of season have a variable effect on landscape as well. Parkes returns instinctively to plant his easel at a nearby community garden known as Quail Hill in Amagansett. A curiously haphazard arrangement of trees in a sloping meadow coupled with a raking afternoon light unfailingly deliver the emotional qualities he seeks. In summer, a dappled cloak of shade on the green grass indicates foliage flurrying in an energetic wind (below); in late autumn, skeletal limbs cast a shadowy membrane across a leaf-strewn ground the color of burlap (p. 37). In these familiar spots, the artist's assured technique is palpable. One senses there is nothing tentative in his brushstroke, which is free and open, or in his command of spatial relationships. "I can just smell a good picture here: the uninhabited hollow, the oblique position of red-berried bushes, a rustling breeze are all simple things that give me pleasure which I cannot otherwise put into words."

Water is another element Parkes paints with felicity. One senses with physical excitement the vigorous motion of the earth's vapors in the curling channel of a Nantucket tidal creek disappearing in the mist (p. 114) or the cool, liquid embrace of Somes Sound, a fjord on Mount Desert Island (p. 128). Just as Constable's clouds billow in cotton-candy contours thereby indicating rolling atmospheric pressure, so the ebb and flow of Parkes's coil-shaped waterways suggest a life force. Sky and water become liberating pictorial ingredients. In his aquatic views, Parkes is skilled at mirroring the moment. One senses an implication of wind in a ripple, a permeating chill in a rolling fog bank, a brackish taste of seaweed and brine on the wet gleam of rocky marine outcroppings, the squint-eyed glare of a sunstruck and glassy sea.

Isolated outposts surrounded by water, islands have had a mystical attraction for artists and travelers for centuries. An acute sense of solitariness goes hand in hand

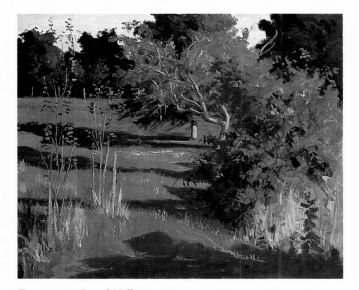

Evening at Quail Hill

with island life. Silhouetted against the sky, an island's timbered horizon is subject to a constant flux of weather. One moment, a shrouding gray veil appears to threaten its very existence; the next a penetrating ray of light brings territory back into focus. Parkes has trundled with his easel to numerous island destinations, preferring to beat a path to unkempt ground. He likes to paint the honey-colored ledges at Gay Head, Martha's Vineyard, the eel-shaped inlets of Madaket on the southwestern tip of Nantucket, or the relentless wilderness of Cadillac Mountain on Mount Desert and the neighboring bald rocks skirting Frenchman Bay, Maine.

Varied topography and inclement conditions indigenous to shore land appeal to his imagination. Marshes, salt ponds, wetlands, blueberry barrens, cranberry bogs, burnished cliffs, dune grass, fleecy clouds, and frothy fog are the backbone of his work. Occasionally, man-made articles slip into the forefront although Parkes is wary of a picture "becoming a little more commercial" when a lighthouse, an abandoned dinghy, or sailboats moored safely in a cove come into play. However, these elements must be indulged if they appear there naturally. "The effect of water reflecting off a polished hull forces me to paint that likeness and perhaps even a better picture in the end," he says. The implicit gravity of a vessel afloat is a difficult balance to achieve but Parkes manages to indicate convincingly the instability of a kayak or canoe sitting in water. In his depiction of Chatham Harbor, a slight zephyr topples whitecaps across the bay while the rocking motion of masts is implied as they list unevenly in the distance (pp. 108–09).

For Parkes there is a tangible tension between natural and man-made substances. He confronts the complexity by striving for equilibrium and rationalizing a particular vantage point from which to paint. For instance, in *Chatham Lighthouse* (p. 111) he abbreviates the pillared structure, a barely noticeable bump on the distant plane, rendering it incidental. It is as if the round tower has mellowed into the horizon. By contrast, in *Sankaty Lighthouse, Nantucket* (p. 98) he confronts its columnar form boldly, allowing its red-striped torso to soar without apology toward the

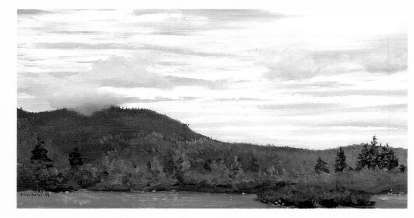

Beech Hill, Mount Desert

heavens. The heroic depiction is atypical. The foreground and fair-weather clouds are deliberately unfinished, an artistic conceit that contributes to the luminosity of the painting while allowing the enduring symbol to command the horizon.

Parkes does not paint many edifices in relationship to an overall landscape, preferring to treat any architecture as its own entity and the unabashed focal point of a composition. "House portraiture is difficult and sometimes requires its own space," he explains. *Coast Guard Station, Martha's Vineyard* (p. 1) portrays a gabled portal and whitewashed facade. The painting's small size emphasizes the architectural scale of the door and transom. Devoid of topographical context, well-defined shadows convey information about the weather. The painting indicates vividly an atmospheric mood, a snack of sunshine on a clear day, although no sky is visibly represented. Similarly, in the abstract *Scheerers' Porch, East Hampton* (p. 71) the linear convergence of shadows on the corner of a columned veranda imparts a slice of a sun-drenched morning.

Emotional attachments to a memorable place, or to a work of art, are often forged by a love of simple pleasures. Perpetually alive in the mind's eye, summer stirs with commingled emotions of nostalgia and anticipation. The familiarity of an uncomplicated continuum year to year is a soothing experience. Simon Parkes tenderly expresses a recognizable world with profound consideration for a way of life that functions naturally. He is committed to ethical observation and devoted to the purity of undisturbed space. His paintings encourage recollection and enable one to observe the honest character of landscape in a fresh light. Hinting at the ineffable, the artist draws one to feel, as if for the first time, the precarious nature of rickety stilts impaling fragile dunes, to discern subtle hues manifested in a monochrome cloud creation, or to hear the weary, wet whisper of wooden harbor pilings groaning in the mist. Arousing memories of lolling summer hours that enhance the whole of life, his *plein air* landscapes welcome a dialogue with the natural world and beckon a swift return to familiar haunts.

OVERLEAF:
Gardiner's Bay

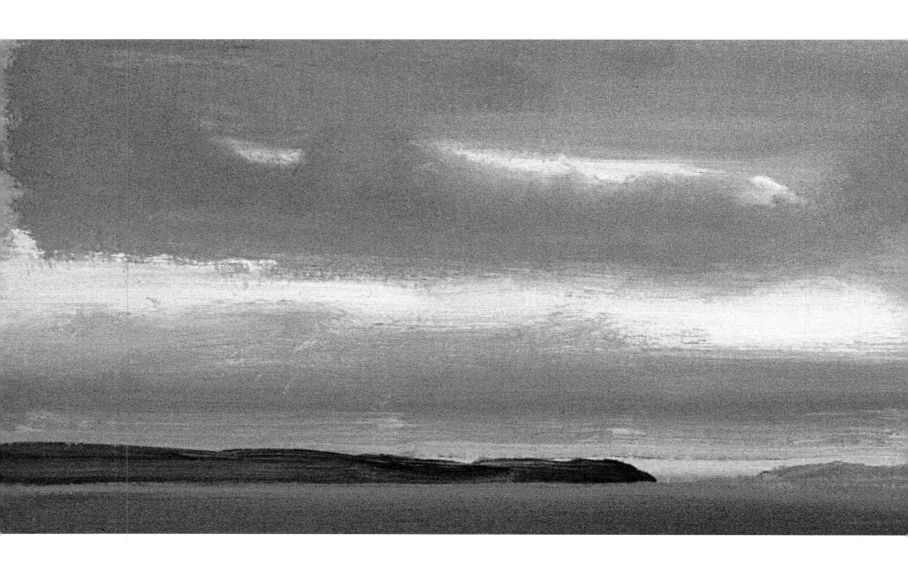

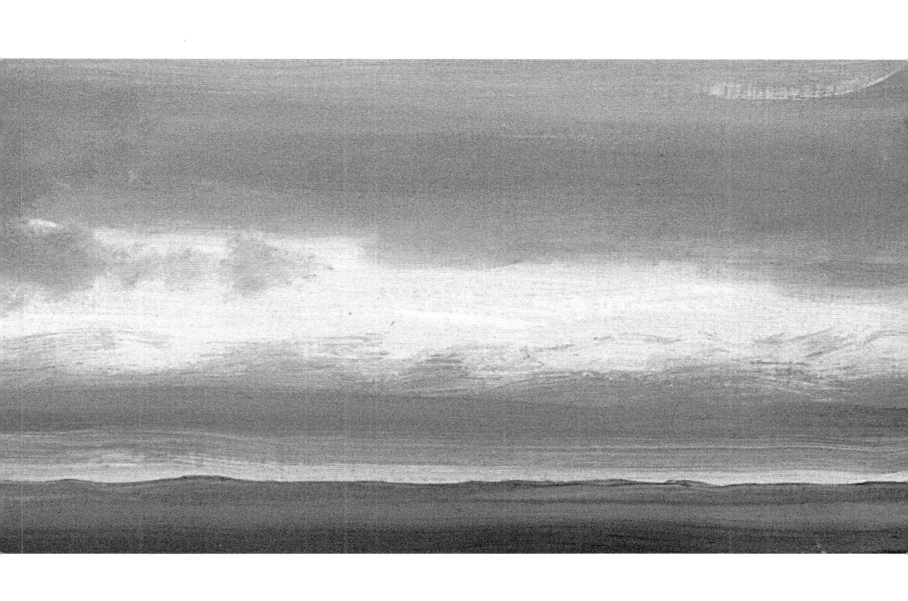

Eastern Long Island

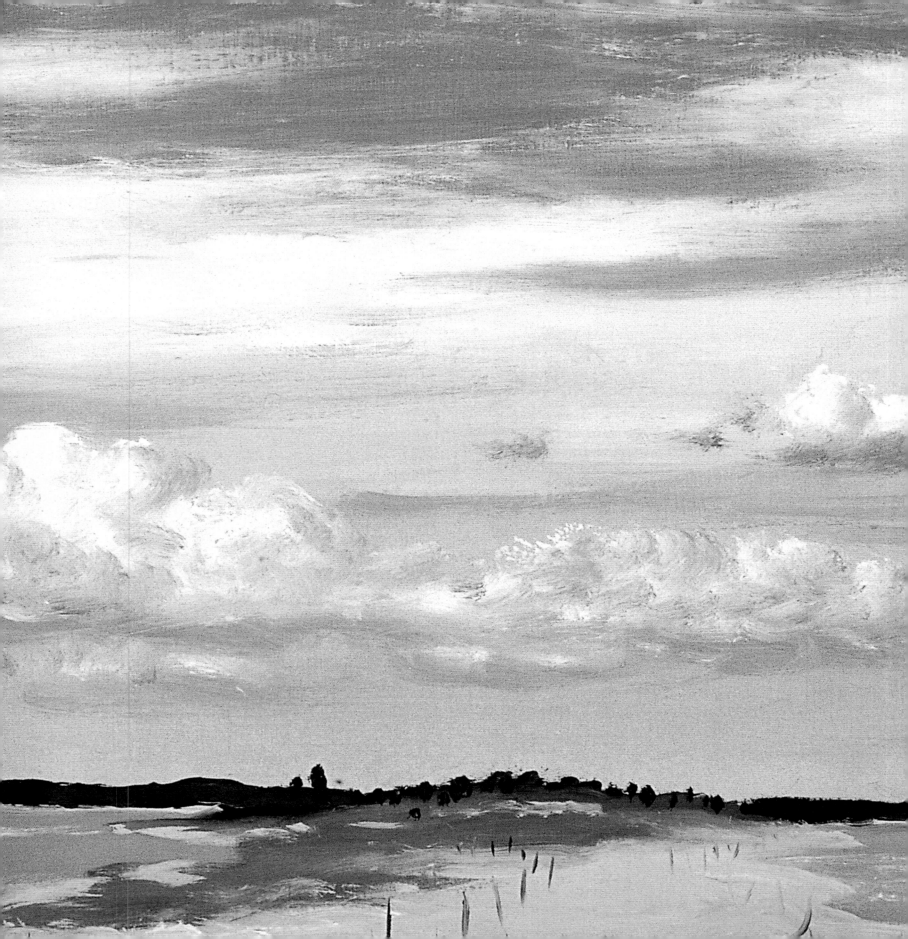

The eastern end of Long Island reaches its jagged pincers into Gardiner's Bay as if attempting to claw a restless sea. The geological origin of the sinewy land mass is a souvenir of the last ice age, a terminal moraine of the Wisconsin glacier, which deposited gravel, clay, and sand as it retreated to the Arctic. Bounded by the Long Island Sound to the north and the Atlantic Ocean to the south, its arable soil was first cultivated by native Americans. High bluffs, horse farms, and recently planted wine vineyards dominate the North Fork. The south shore is distinguished by an unbroken succession of wide beaches and windswept shoals that have attracted affluent settlers to its edge since the late nineteenth century. The communities that settled in and around Fire Island, Quogue, the Hamptons, and Montauk were largely established with a sea view in mind. By contrast, local farmers have long considered the granular dunes as insignificant as dust, naturally preferring the fertile loam and gentle rise of rolling inland pasture and freshwater brooks.

In the mid-nineteenth century, Long Island's seafaring industries changed from whaling to shellfish. Oysters, clams, and scallops scooped by the ton from its bays and estuaries brought a taste of the sea back to New York City. The rapid growth of the Long Island Rail Road and improved roadways aided the fisheries and facilitated tourist expansion as well. An initial track stretched from Brooklyn

Cedar Point

21

to Greenport at the north end; a second line that extended southeast as far as Bridgehampton was completed in 1870. Well-to-do New Yorkers enjoyed general prosperity following the Civil War, and Long Island offered leisurely alternatives to all types of people. From the amusement parks of Coney Island to the invigorating surf that splashed bathers along its southern spits of sand, the entire length of the island was quickly developed as a welcome rural diversion.

Celebrated American artists further helped to lead the way. In the 1870s, a young and enterprising group of New Yorkers founded the Tile Club, an organization that met to paint decorative tiles and discuss art. Winslow Homer, Julian Alden Weir, and John Twachtman were all prominent members. The society made its first pilgrimage by train to eastern Long Island in 1879 and the foray was chronicled and illustrated in *Scribner's Monthly,* a social magazine of the day. The lively account of artists at play promoted Long Island's many attractions and helped prompt carefree city dwellers to discover the region's natural beauty.

American Impressionist William Merritt Chase ventured around 1890 to the Shinnecock Hills located near the village of Southampton. At the invitation of Mrs. William Hoyt, Chase met Mrs. Henry Kirke Porter and Samuel Parrish, who eventually convinced him to join their efforts in establishing the Shinnecock Hills Summer School of Art. A principal teacher there until 1902, Chase was also an avid *plein air* painter who urged his students to draw inspiration from nature. "Take the first thing that you see leaving your door," he insisted. "Anything in nature is good enough to paint... Stop that squinting. Try to see nature as you should, with your eyes wide open."[1]

Chase became something of a local attraction as he endorsed the panorama of his surroundings. His stylish way of life was impressive. He owned a classic, shingle-style house situated on a high point above the dunes. Its broad, columned porch and gabled windows gaped at the sea and commanded a view devoid of competing structures. Vivid and spontaneous, his *plein air* paintings of shrubbery, flowering cactus plants, and fields of profuse wildflowers dappling Long Island's meadows are memorable for their tight composition and vivid color values. The

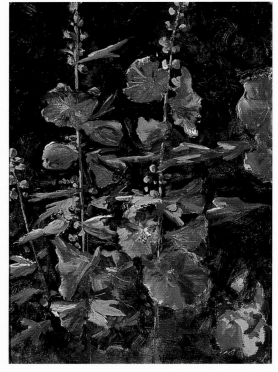

Hollyhocks at Mary Ryan's

artist told his students, "Do not put too much of the same handling in the foreground and middle distance. Break the surface of your shades. They will appear more natural."[2]

Rummaging around for vantage points unblemished by signs of civilization, Simon Parkes parallels the spirit and example set by Chase and his contemporary *plein air* devotees. The modern-day artist atavistically chooses to depict a decidedly rarefied view, one that is peacefully reminiscent of a past era. Positioning his easel next to a bucolic road dissecting Wainscott's open farmland, or in the silent woods at Quail Hill in Amagansett, Parkes is completely content. His assured technique is grounded by enormous respect for values established by earlier nineteenth-century artists like Corot, yet unlike his artistic forebears who often mingled together, Parkes works alone and considers *plein air* outings a solitary endeavor.

In Springs, an area of roomy wetlands and shaded roads north of East Hampton, the island's physical composition retains characteristics similar to those of a hundred years ago. Parkes settles in frequently to paint at a friend's garden on Springs Fireplace Road. He has recently devoted his attention to the property's old

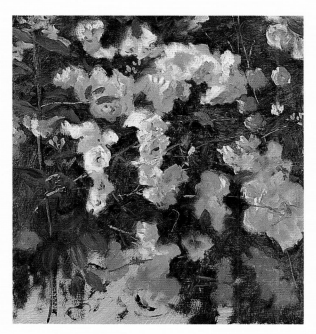

Wild Roses at Mary Ryan's

apple orchard, rose garden, and perennial beds. Focusing tightly on individual blossoms, his botanical studies of hollyhocks are colorful depictions in reds, pinks, mauves, and yellows. Parkes employs a lively touch with nodding flowers (opposite and left) reminiscent of Chase's impressionistic handling.

Surveying the water nearby at Three Mile Harbor, Gardiner's Bay, and Georgica Pond, Parkes values the evanescent qualities of Long Island's early morning and fading evening light. The evocative landscape and consistently mesmerizing confluence of sea and sky represent a vanishing territory, a place he has adopted as a spiritual home for these very reasons. Although the South Fork is now densely populated, and once again a seedbed of artistic activity, Parkes says, "I am not taught or influenced by a living artist, however, while painting on Long Island I do think about predecessors such as William Merritt Chase and Fairfield Porter who painted here before me."

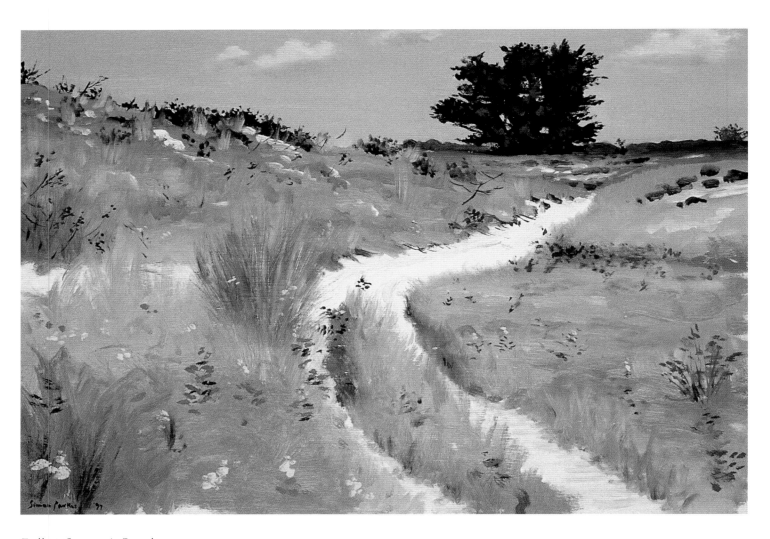

Fall at Sammy's Beach

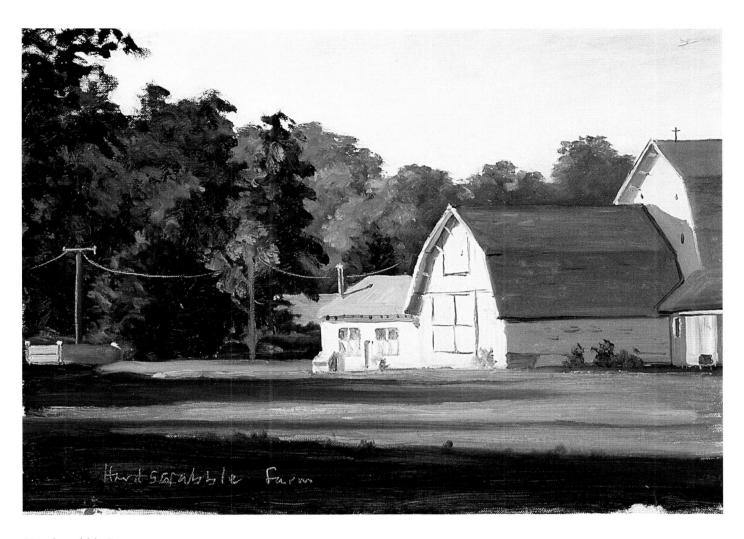

Hardscrabble Farm

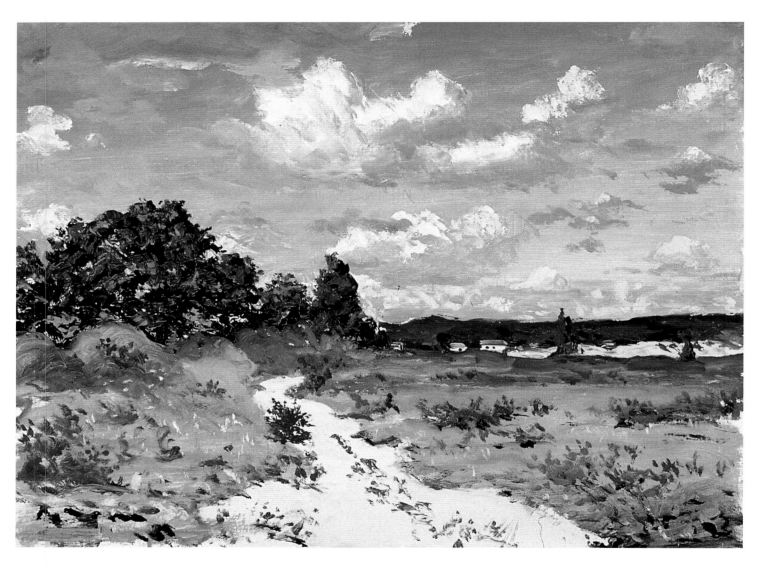

Scattered Clouds, Sammy's Beach

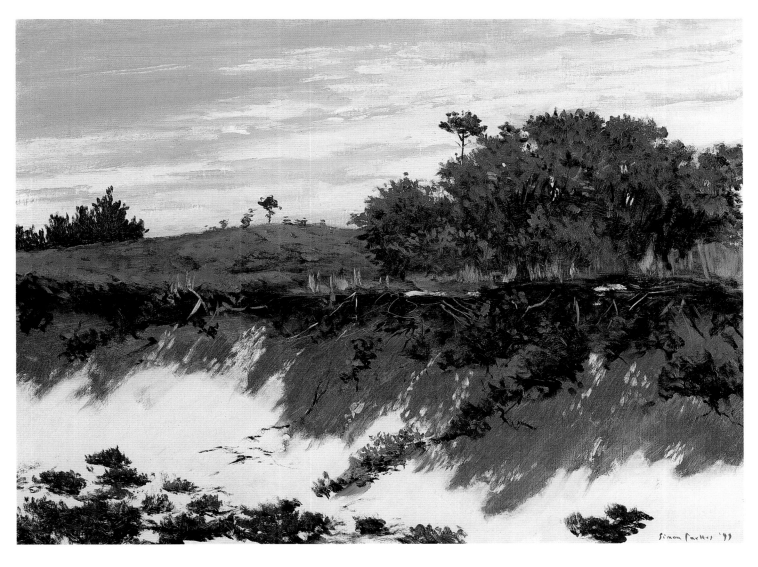

Shadows on Cranberry Hole Road

OVERLEAF:

Gray Day, Late Summer, Georgica Pond

27

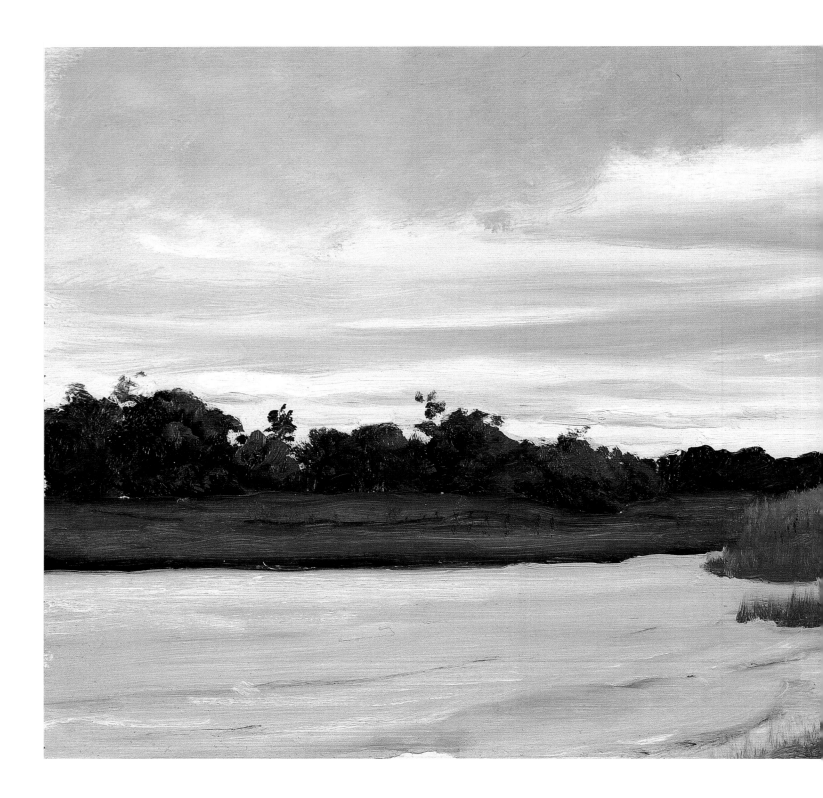

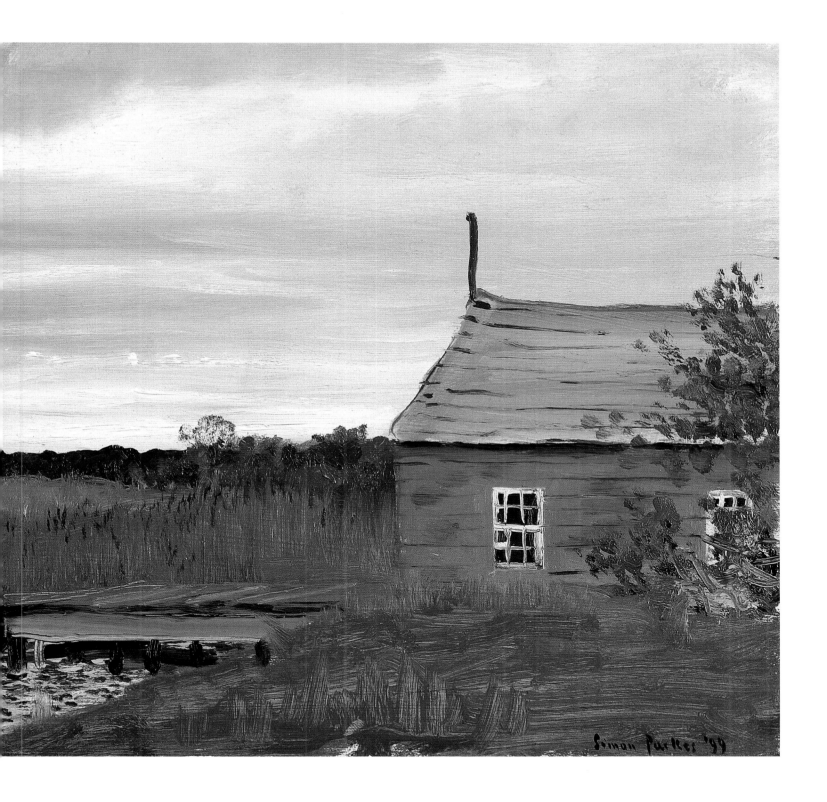

Simon Parkes '99

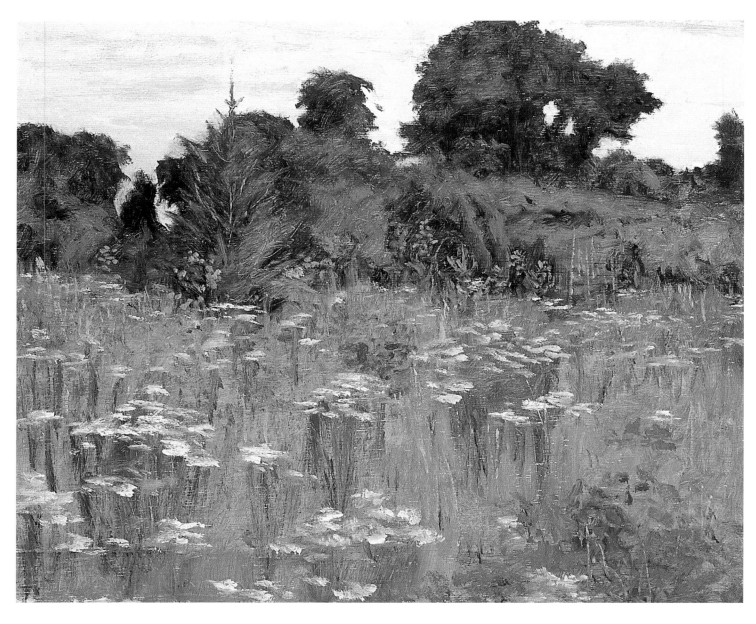

Queen Anne's Lace, Quail Hill

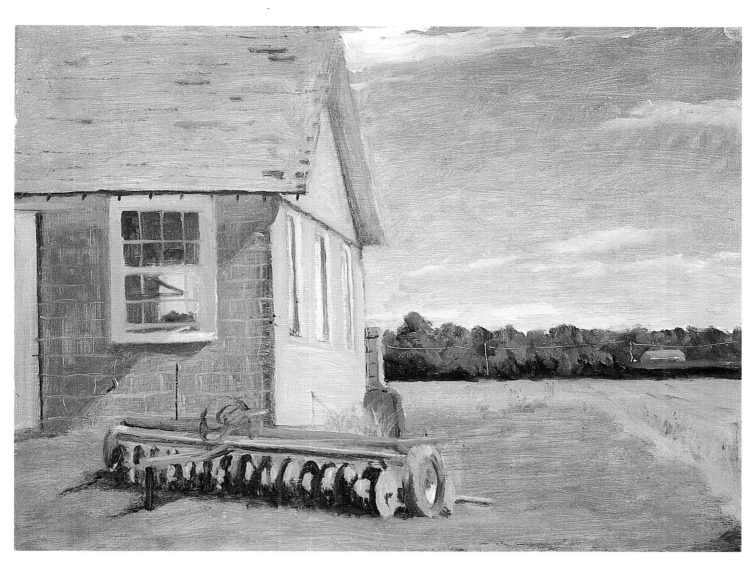

Plough at Hardscrabble Farm

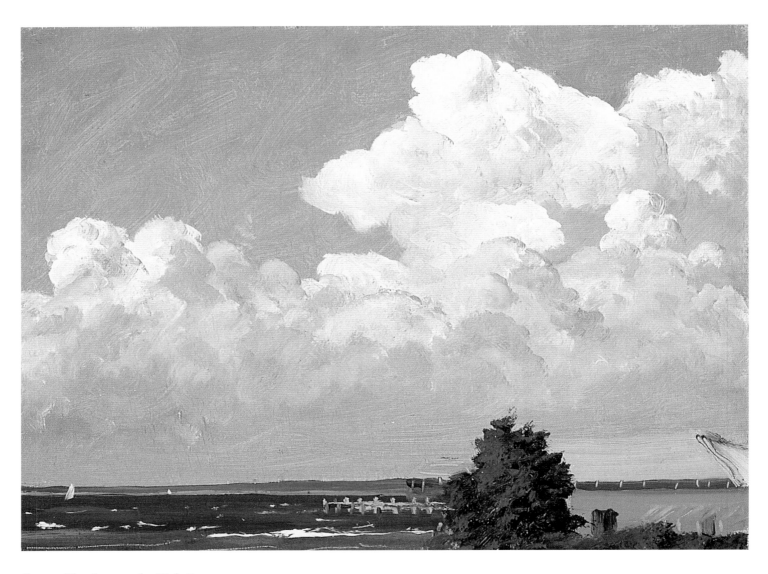

Storm Clouds over the Fish Factory

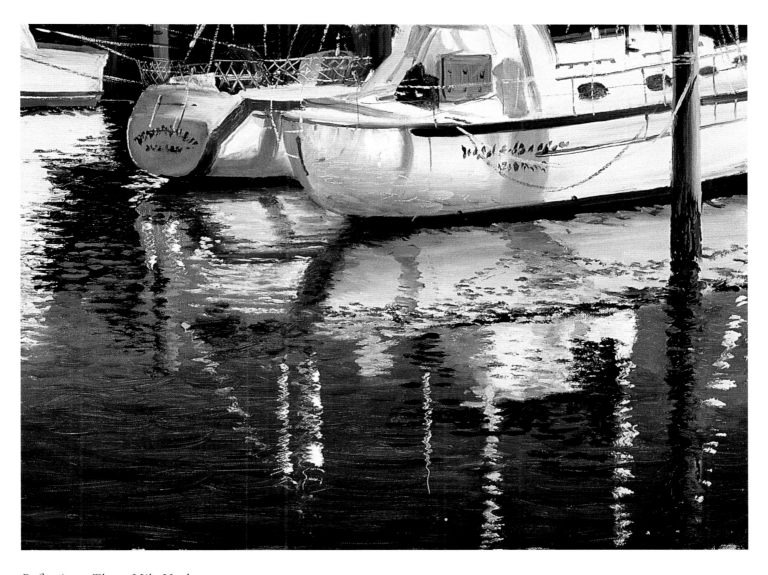

Reflections, Three Mile Harbor

OVERLEAF:
Tractor on Route 114

33

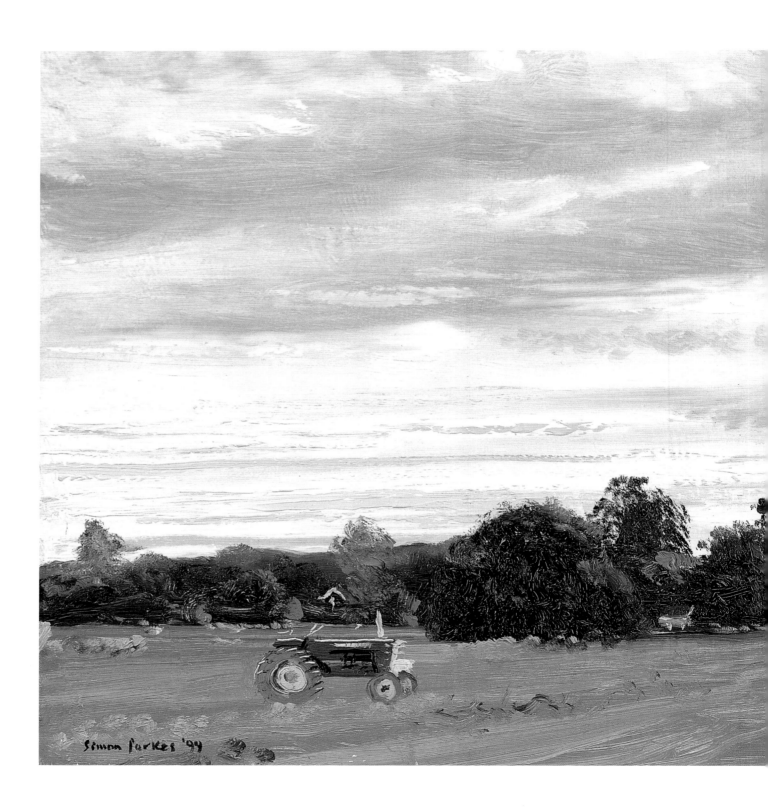

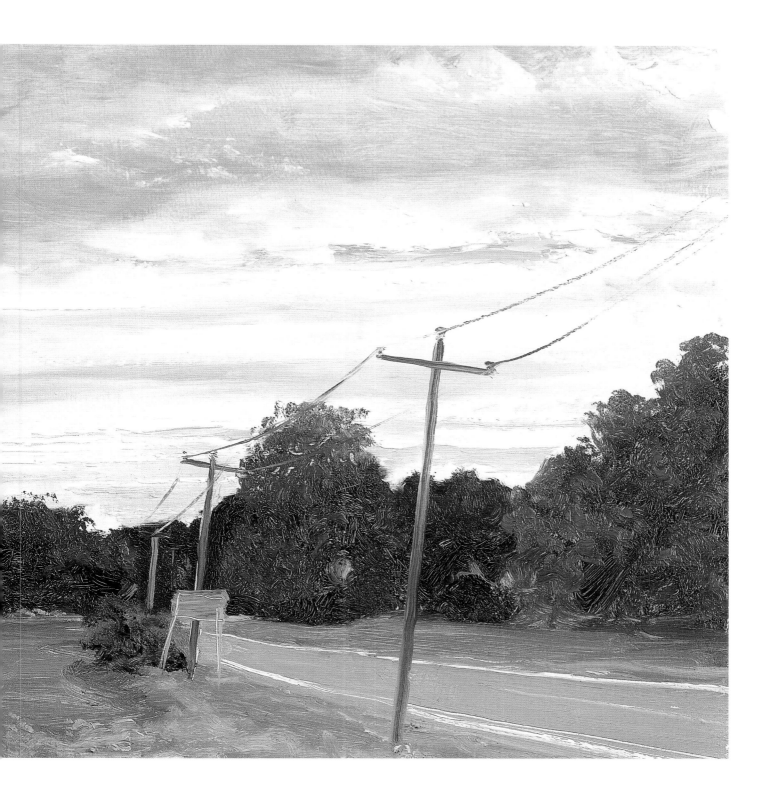

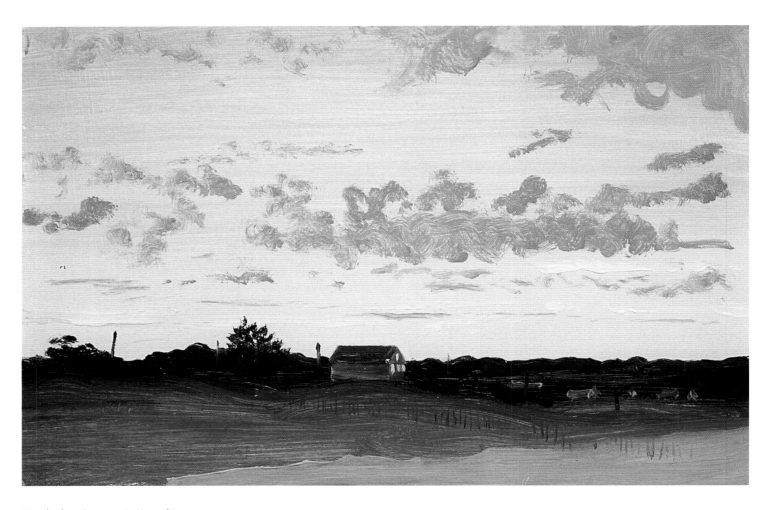

Twilight, Sammy's Beach

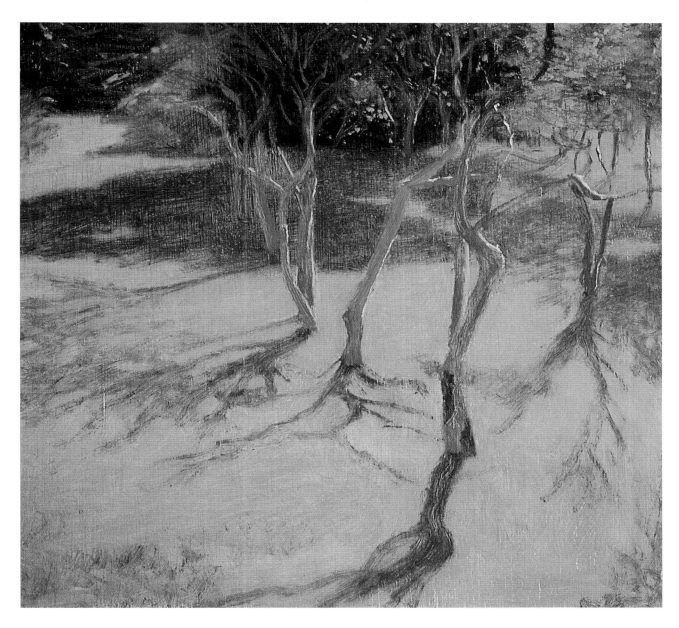

Apple Trees, Quail Hill

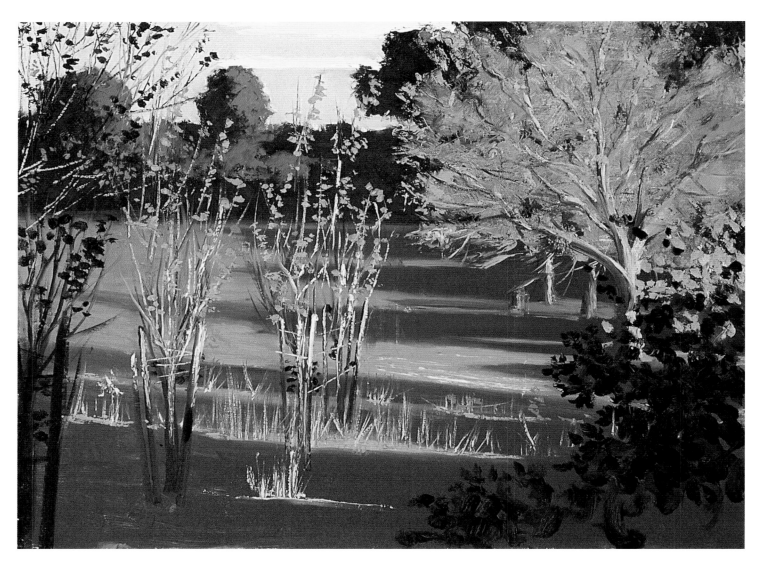

Fall at Quail Hill

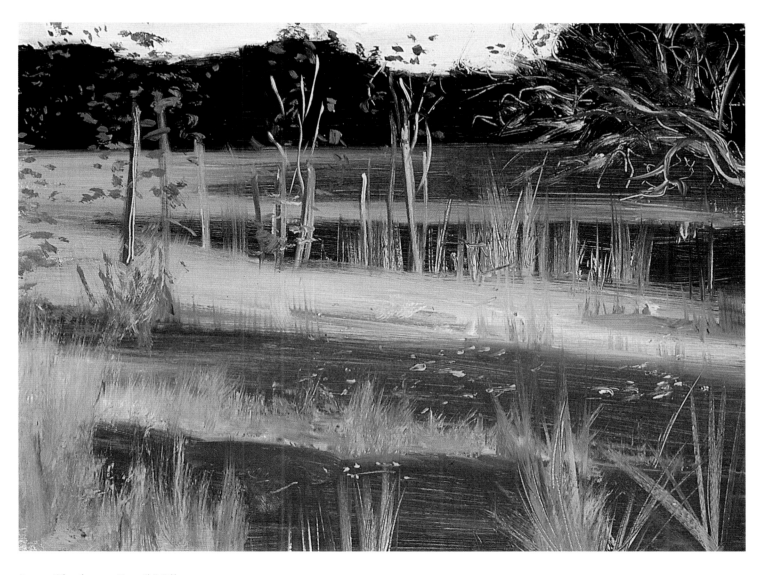

Long Shadows, Quail Hill

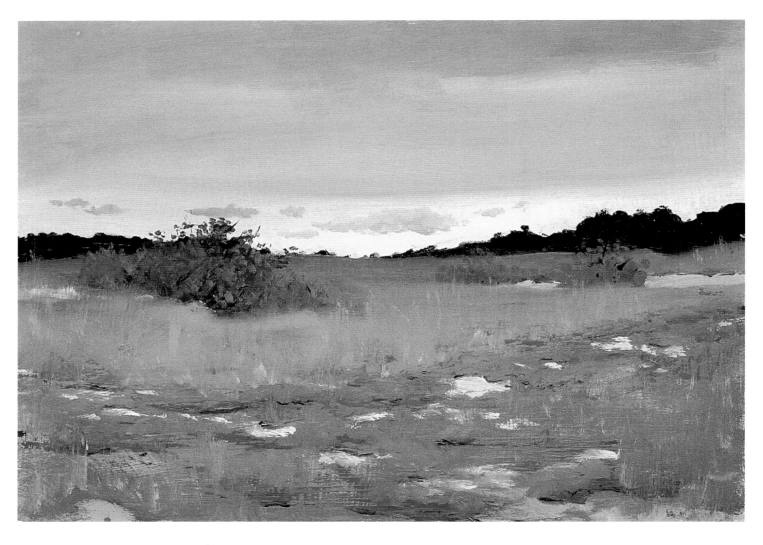

Stormy Evening, Sammy's Beach

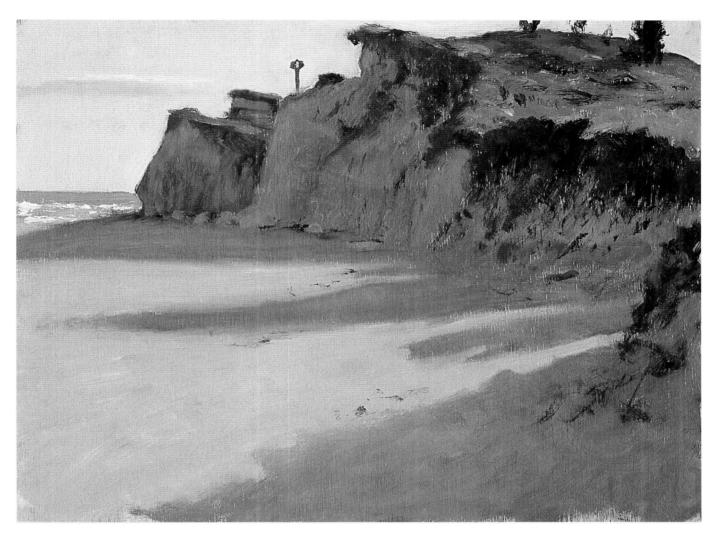

Evening at Ditch Plains, Montauk

OVERLEAF:
Cliffs at Hither Hills, Montauk

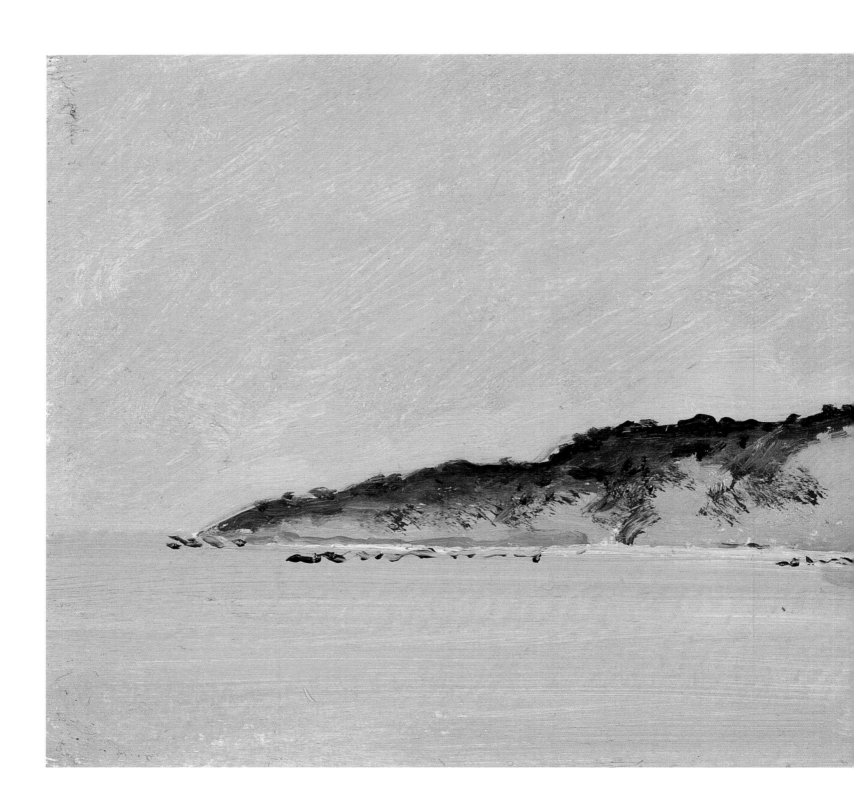

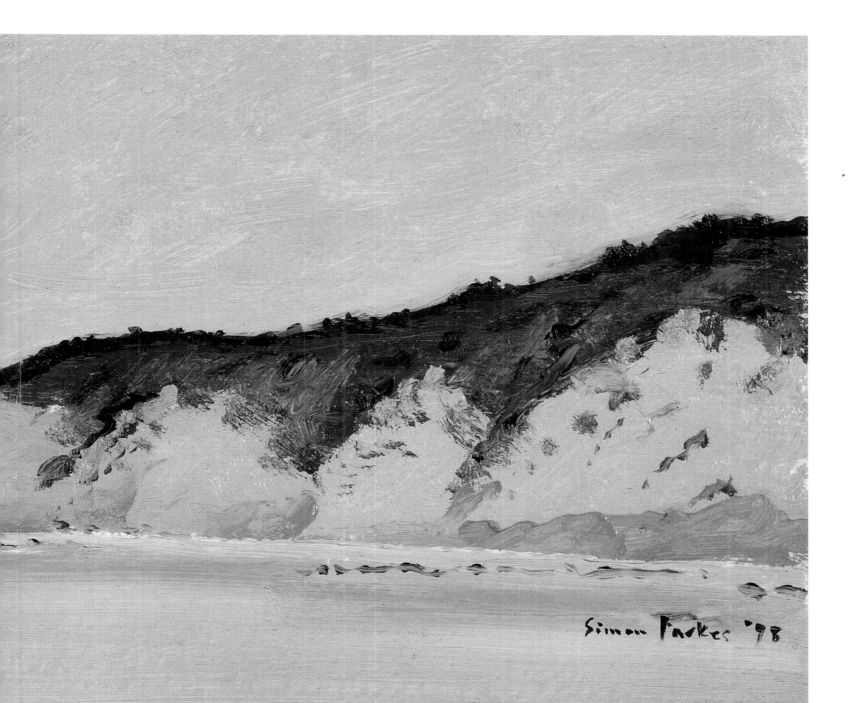

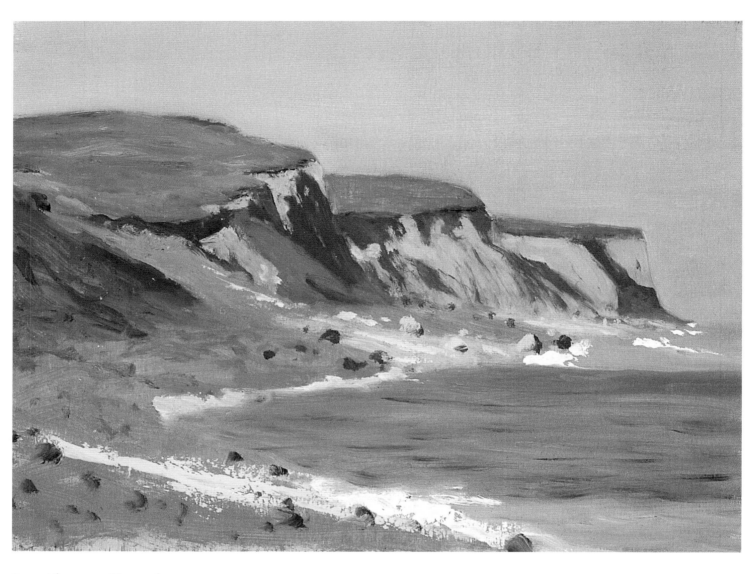

Late Afternoon, Montauk

OPPOSITE: *Sandy Cliff, Montauk*

44

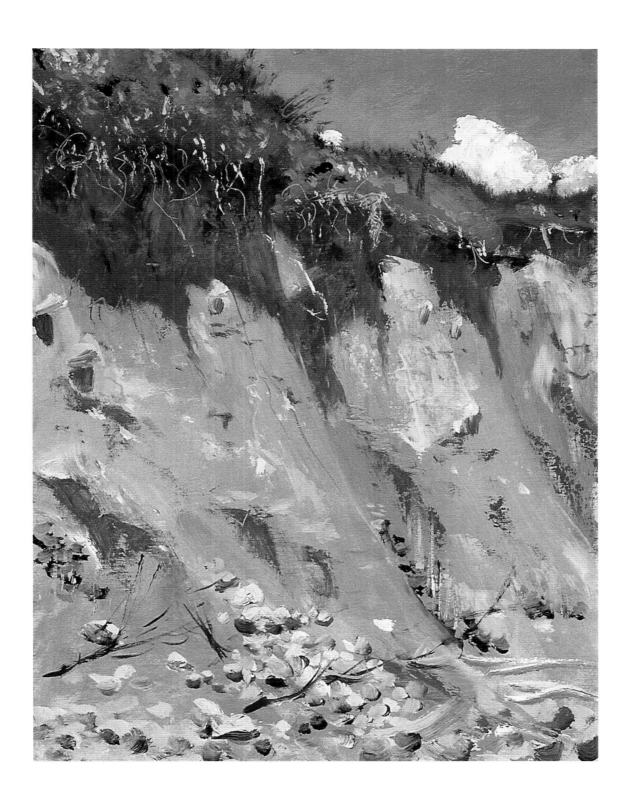

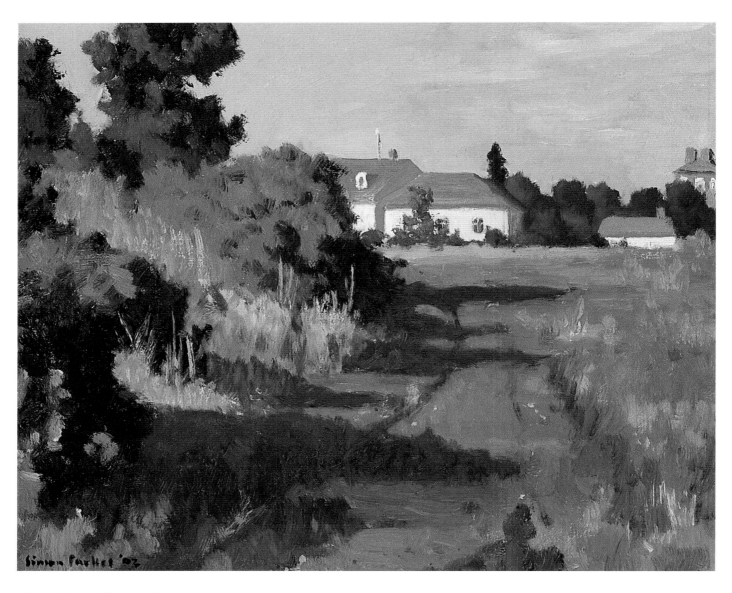

Coast Guard Station, Georgica

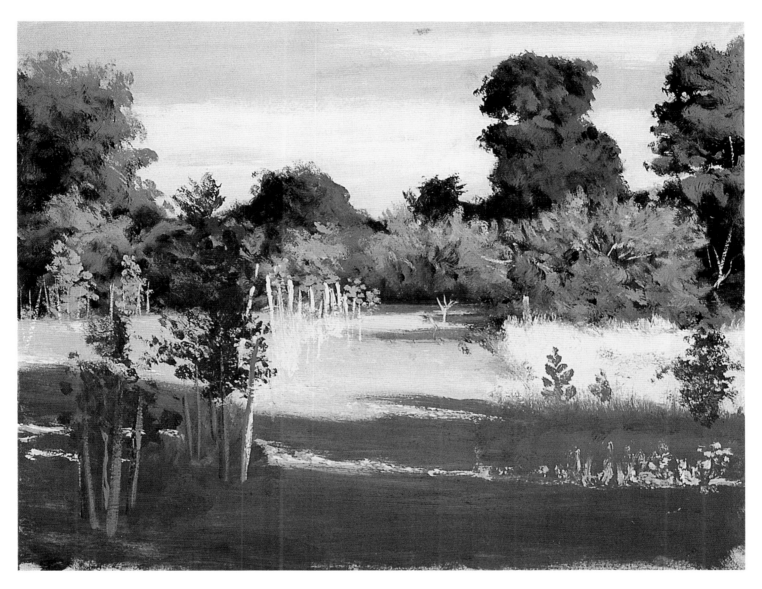

Summer Evening, Quail Hill

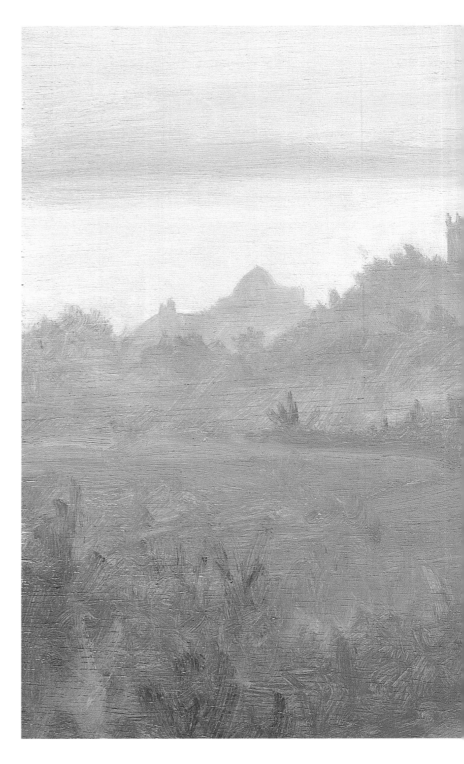

Dunes, West End Road

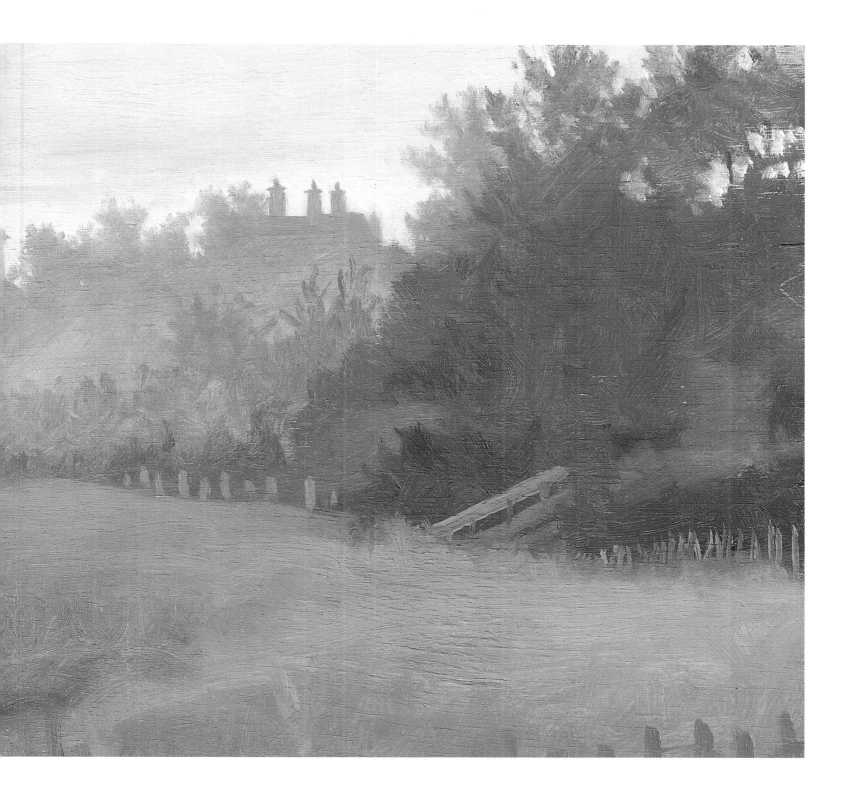

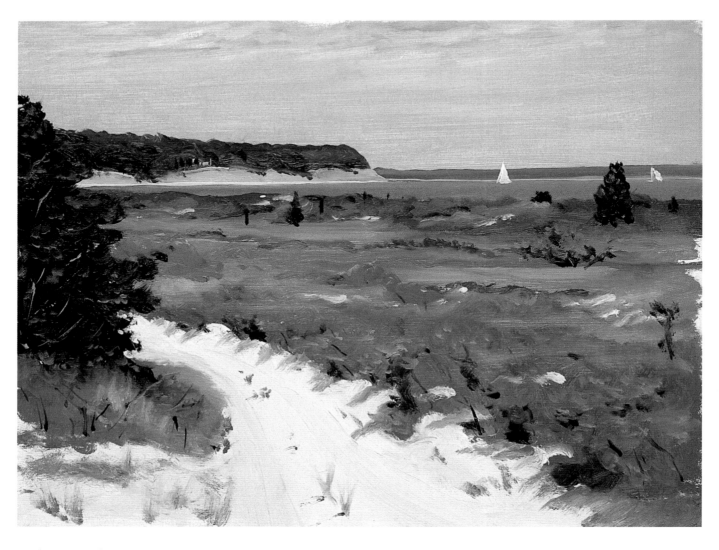

Sails on Gardiner's Bay

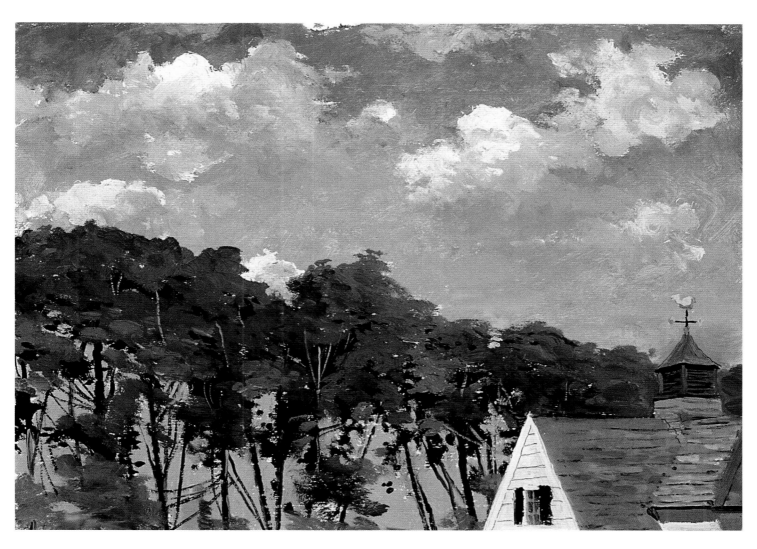

Rooftops, West End Road

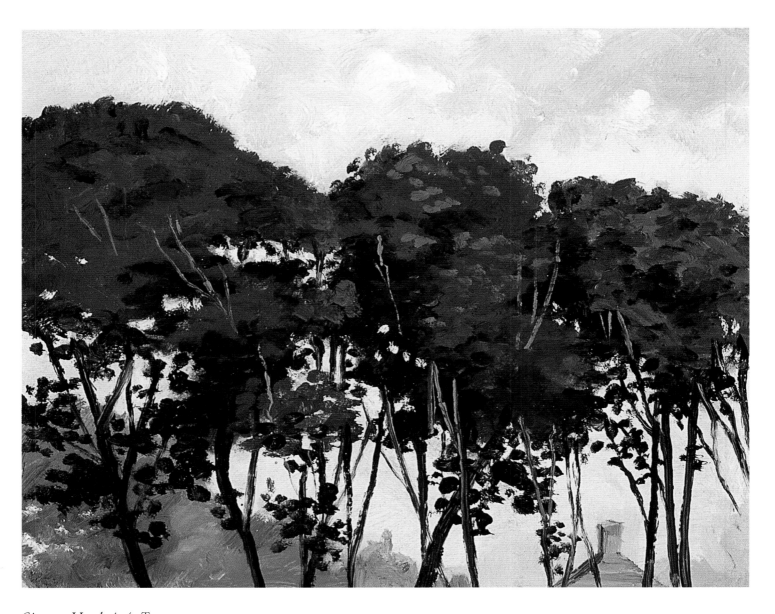

Simone Manheim's Trees

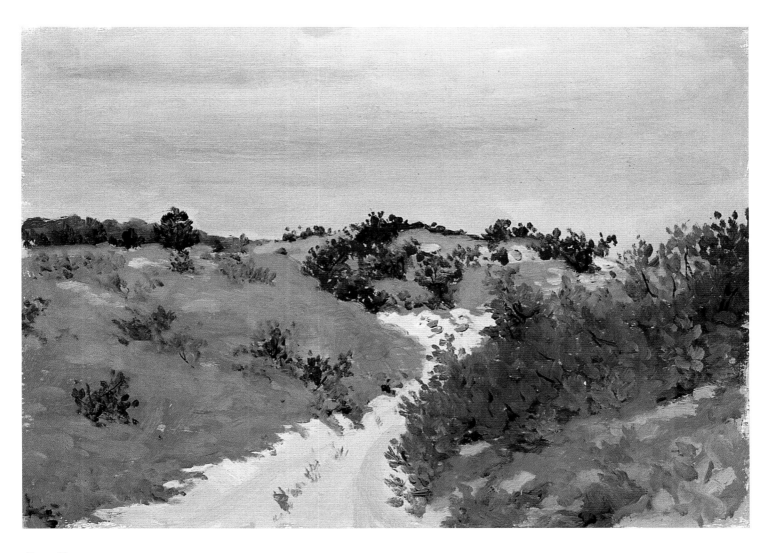

Gray Dunes

OVERLEAF:
Boats at Anchor, Three Mile Harbor

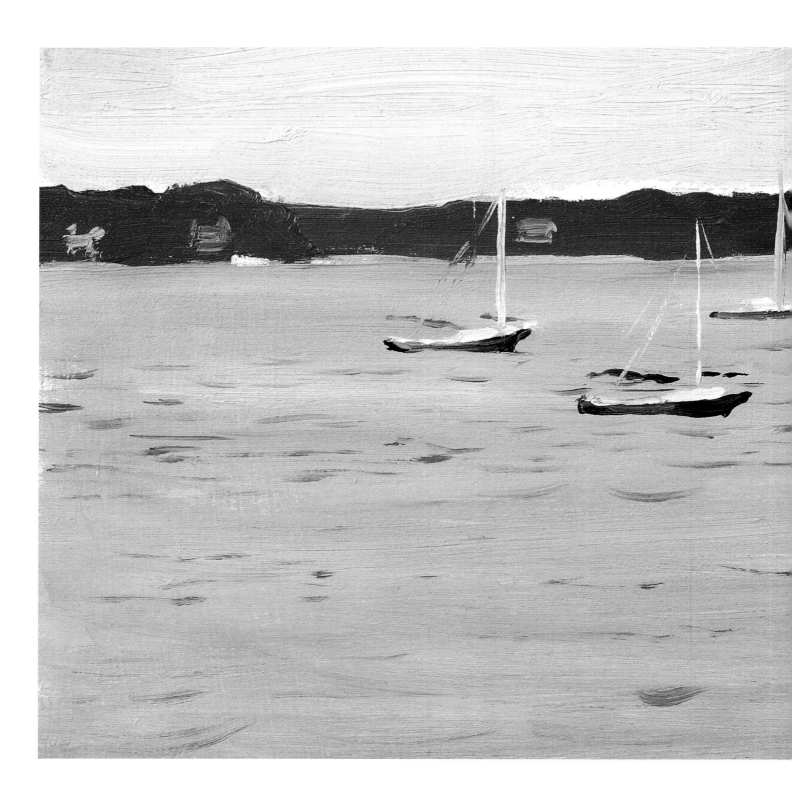

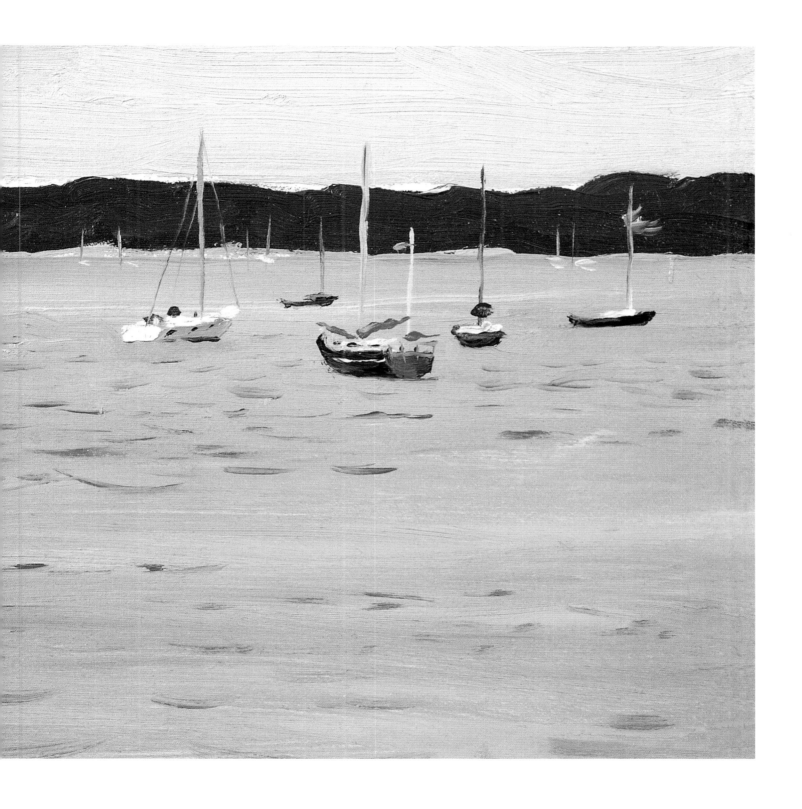

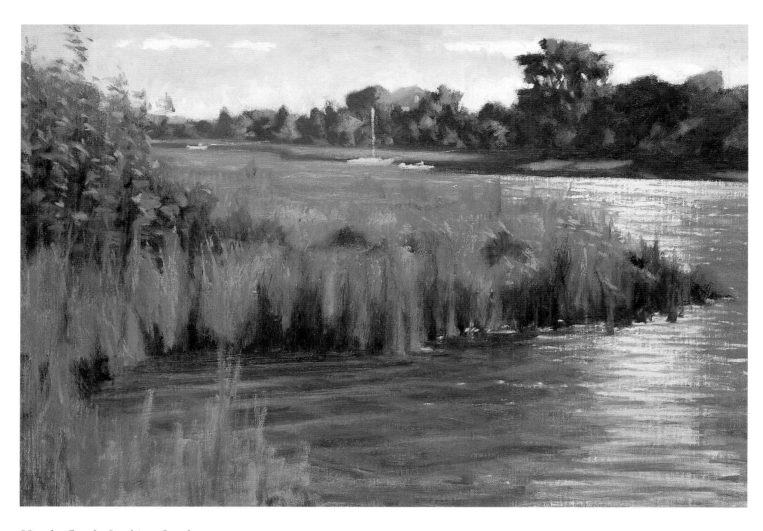

Heady Creek, Looking South

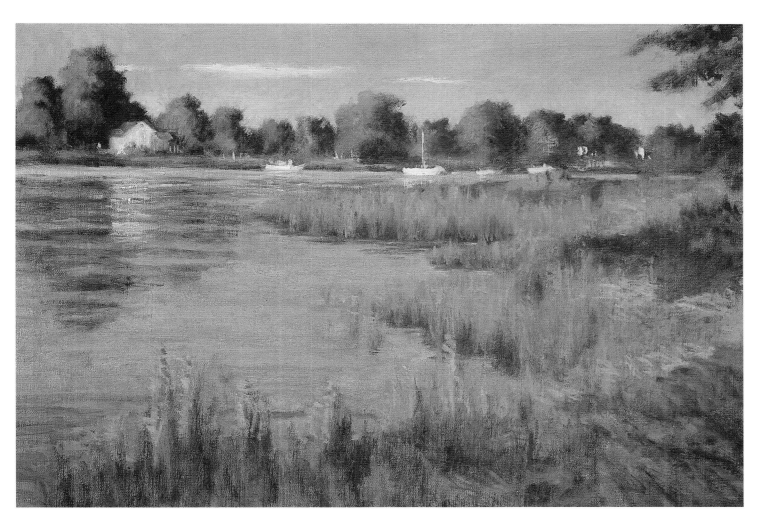

Heady Creek, Looking North

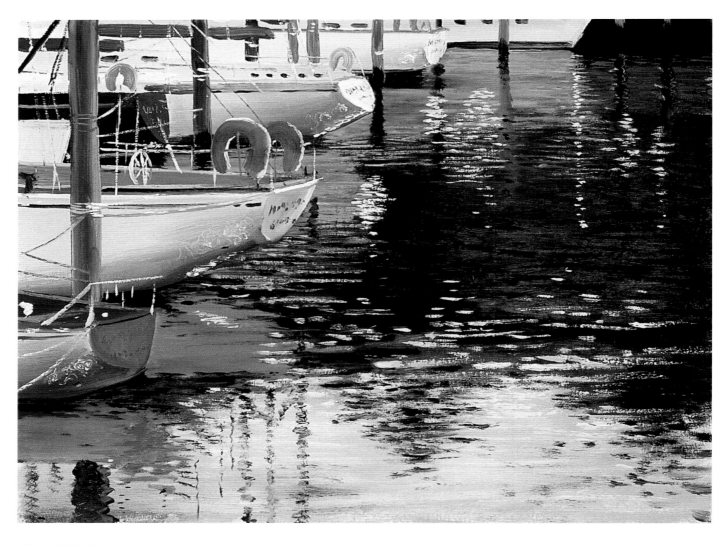

Three Mile Harbor

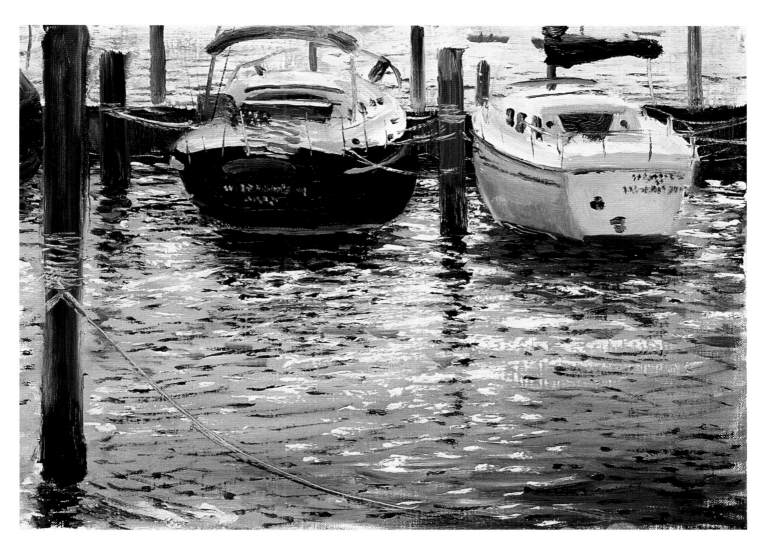

Two Boats, Three Mile Harbor

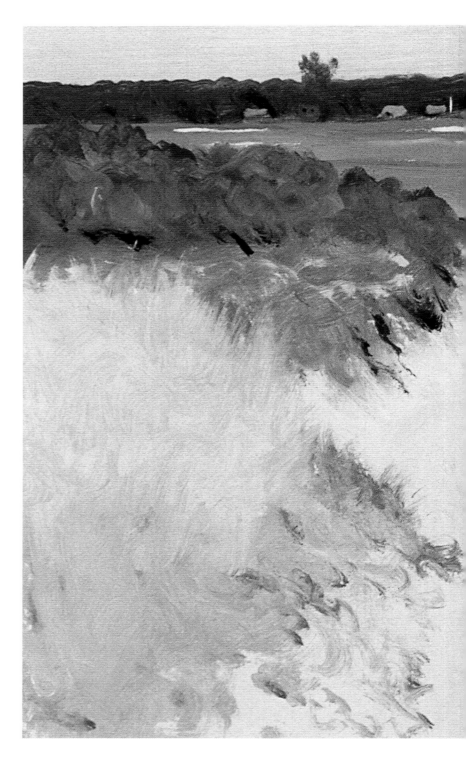

Fall Shadows, Sammy's Beach

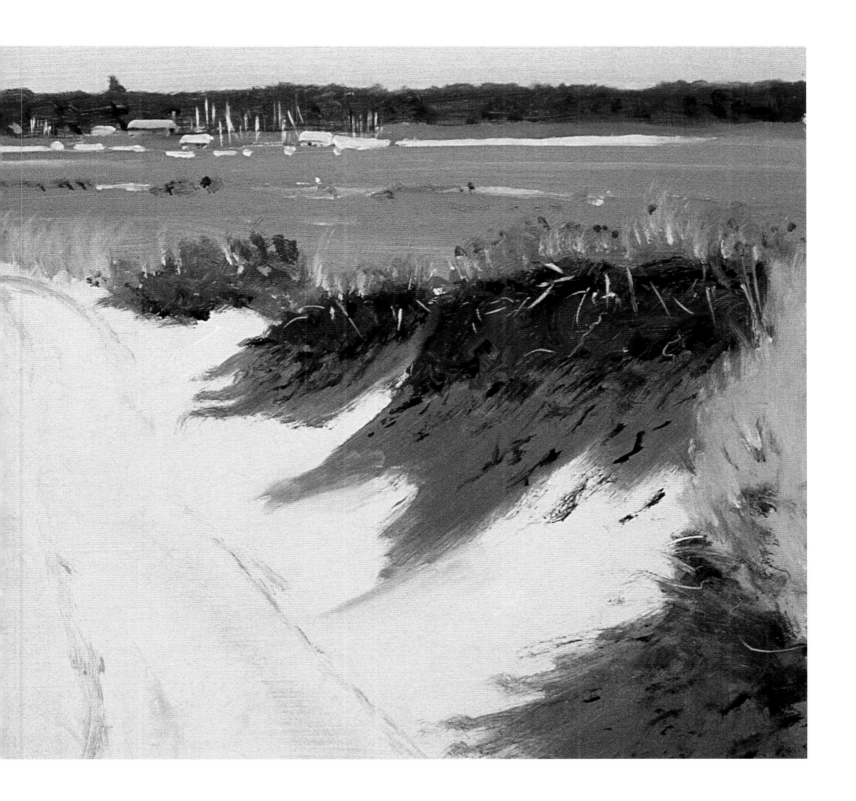

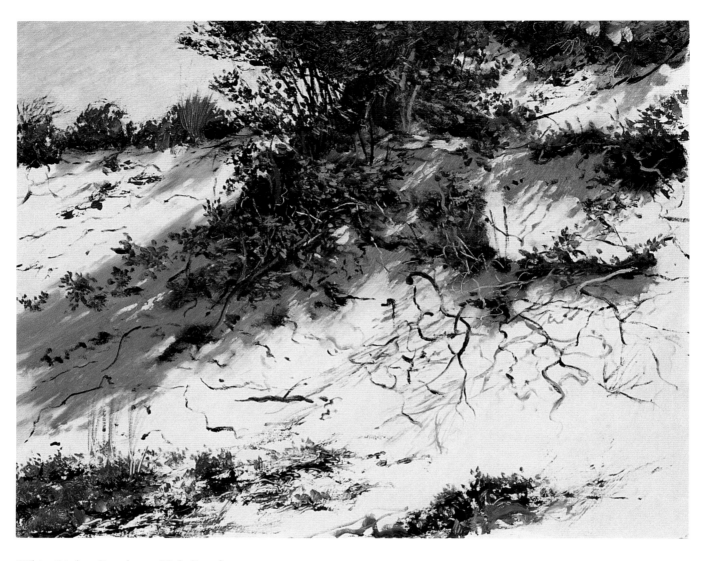

White Light, Cranberry Hole Road

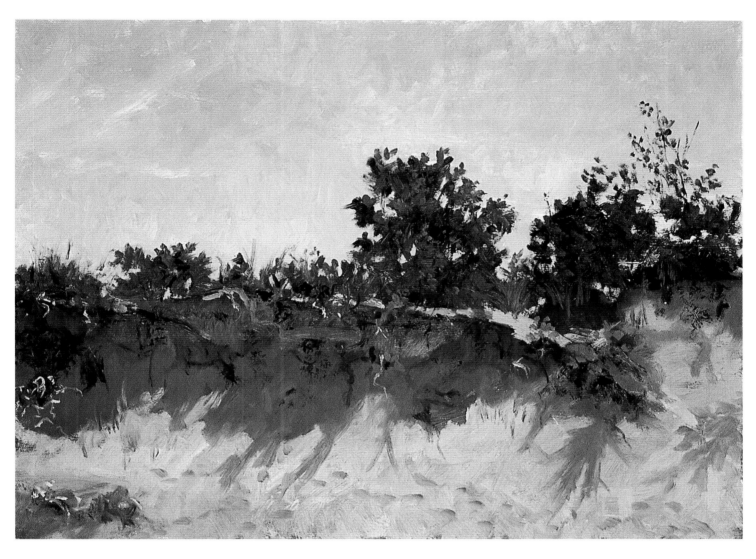

Warm Shadows, Cranberry Hole Road

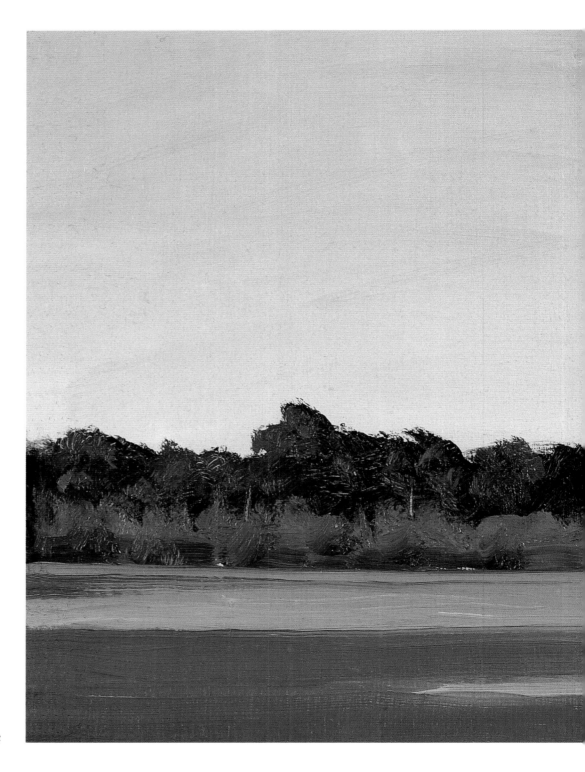

Evening, Long Lane

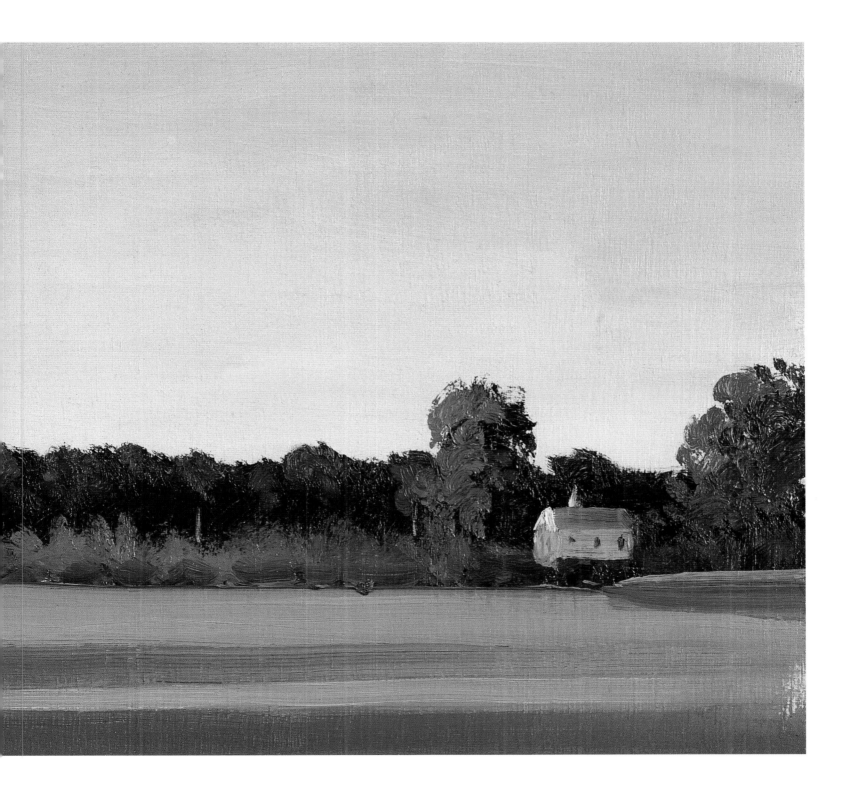

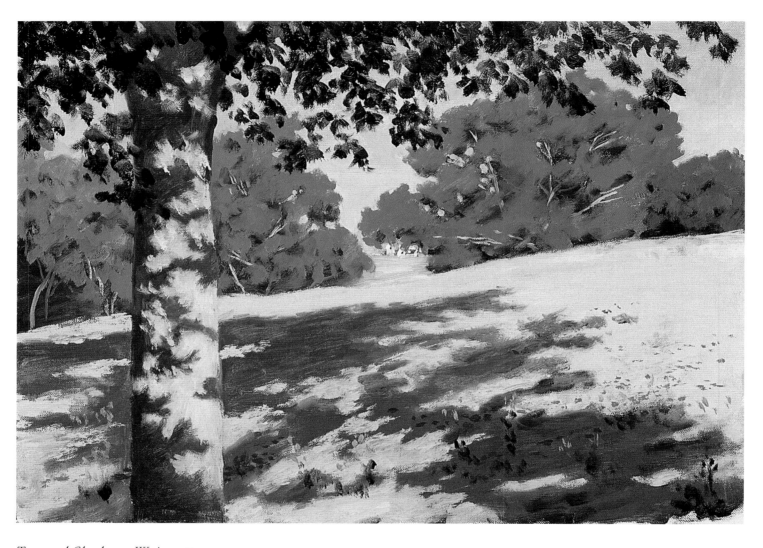

Tree and Shadows, Wainscott

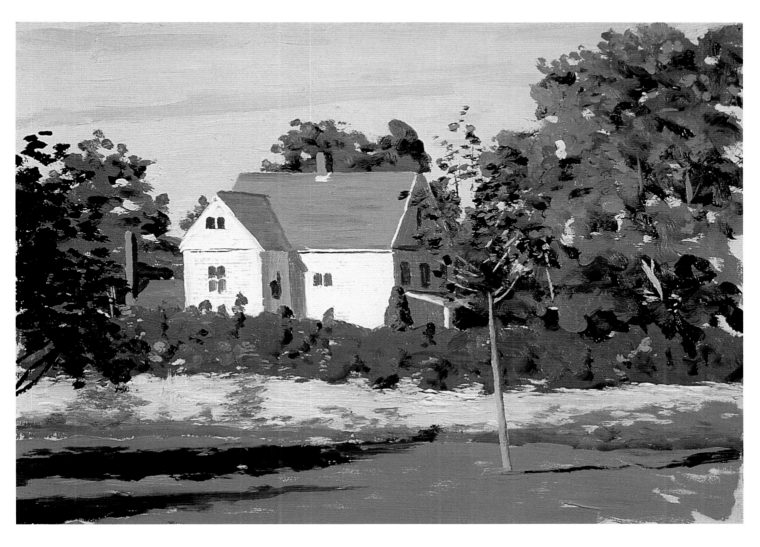

Farmhouse, Wainscott

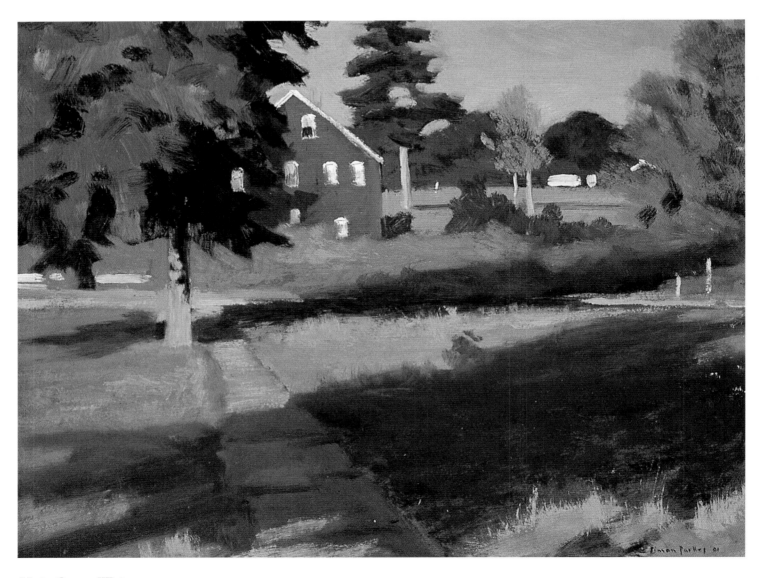

Main Street, Wainscott

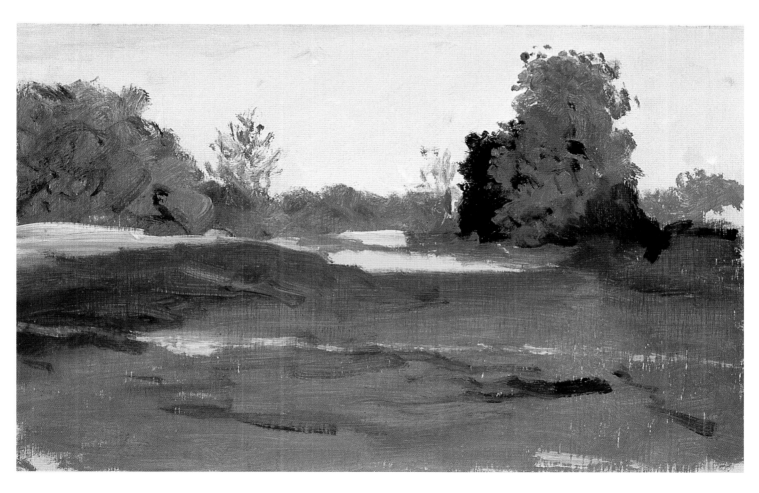

Evening, Route 114

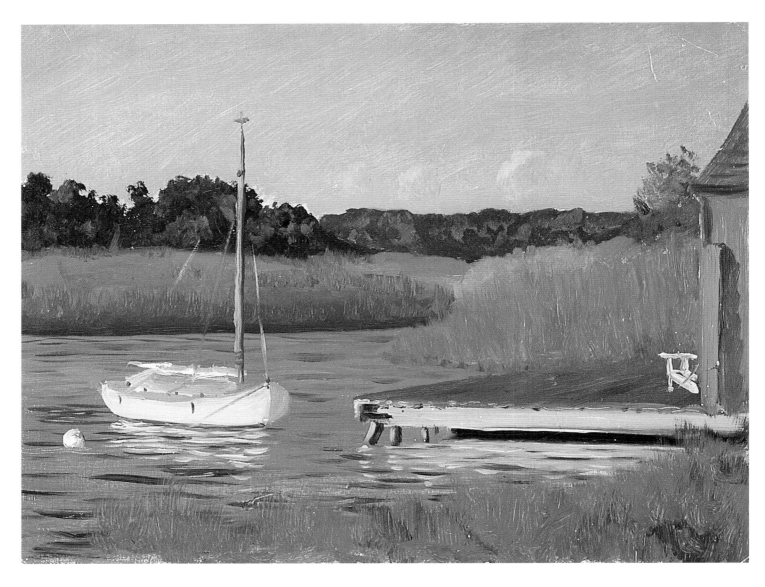

Georgica Pond Boathouse

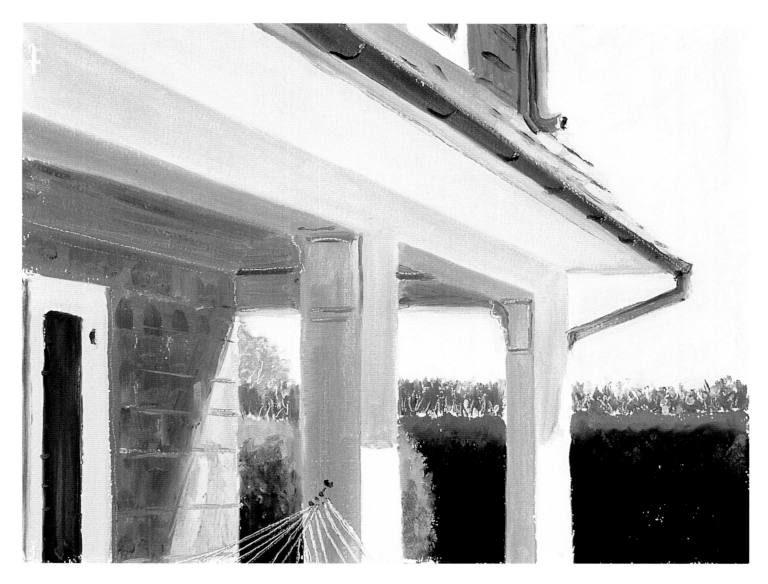

Scheerers' Porch, East Hampton

OVERLEAF:
Georgica Beach

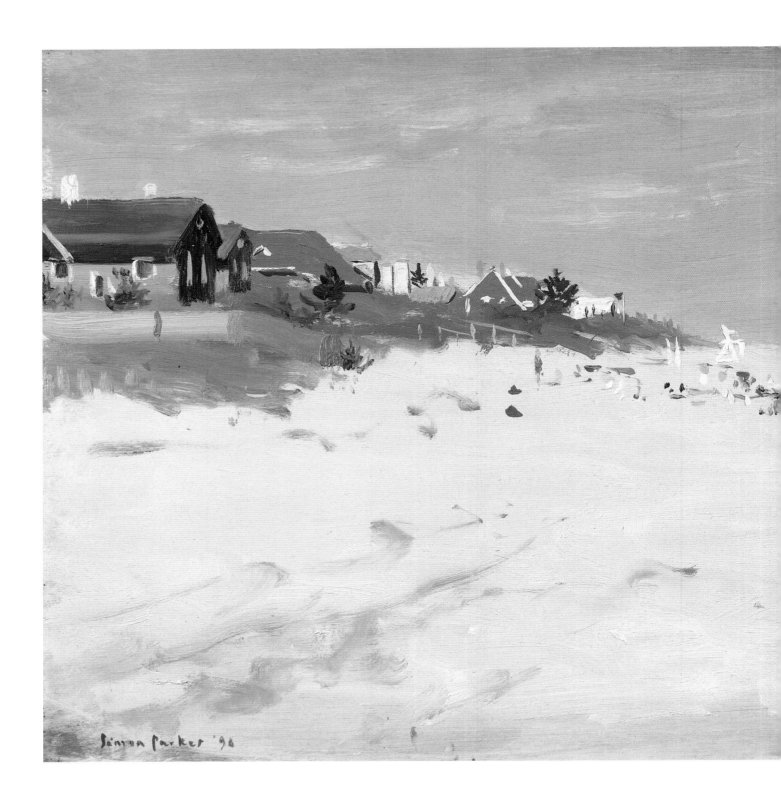

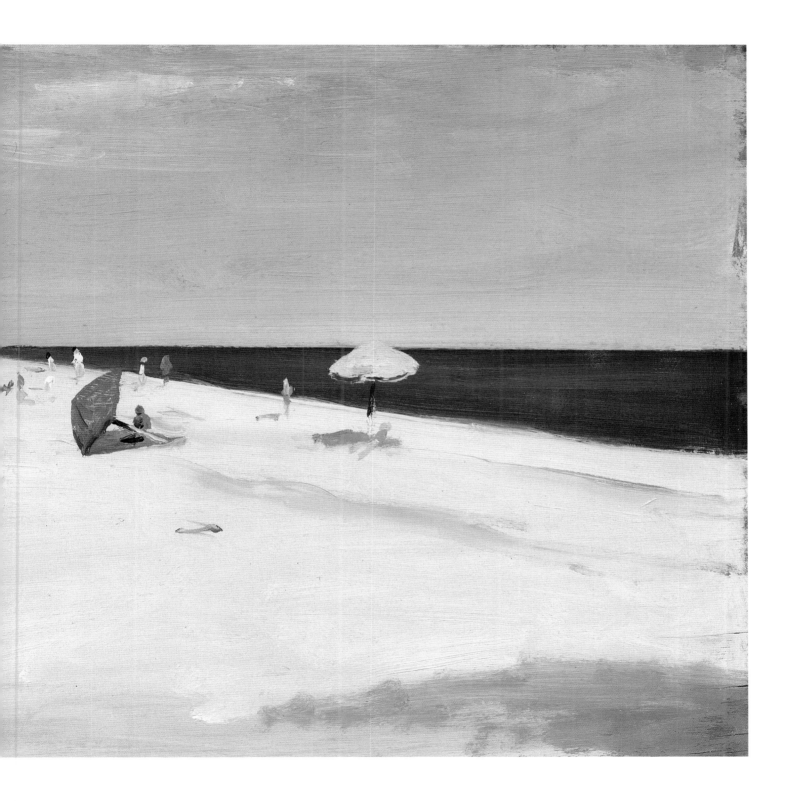

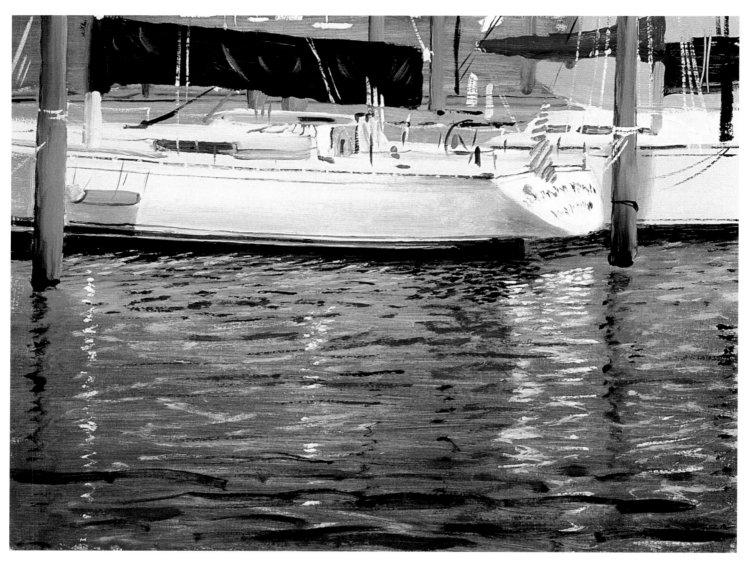

Fourth of July, Three Mile Harbor

OPPOSITE: *Black Boat, Three Mile Harbor*

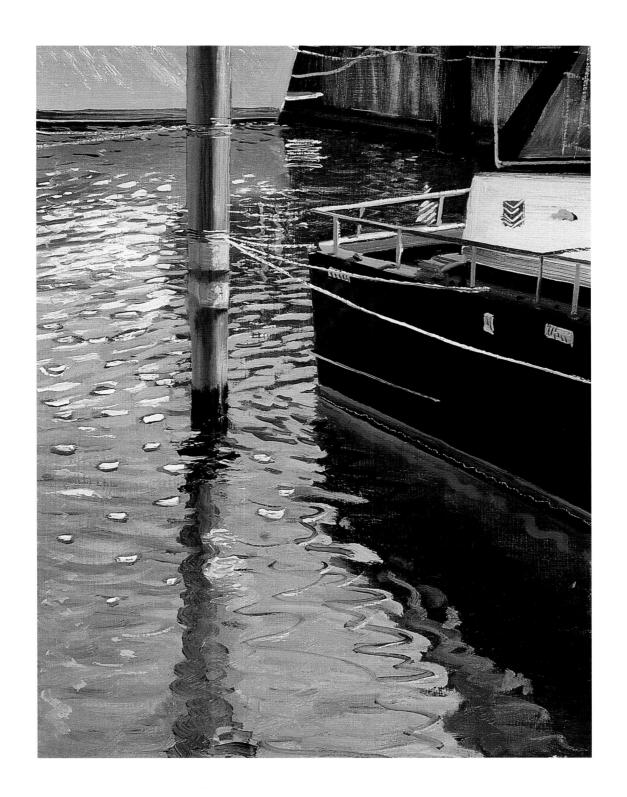

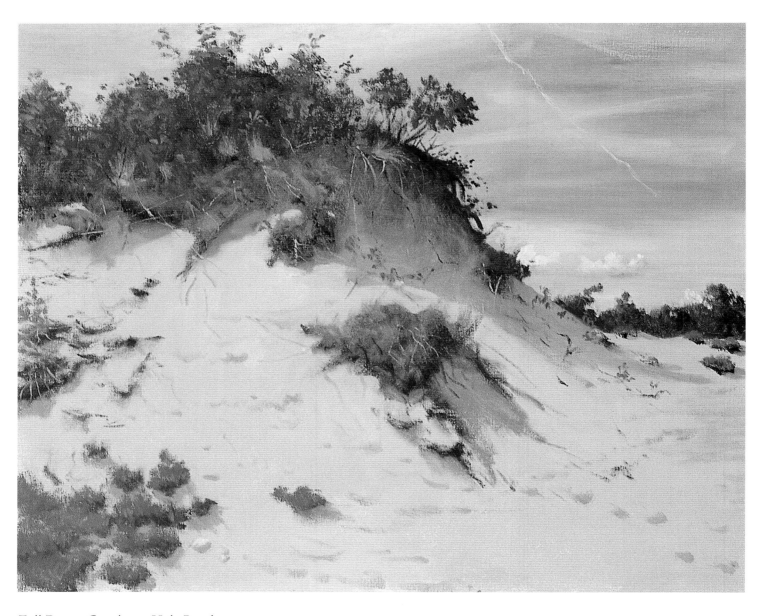

Tall Dune, Cranberry Hole Road

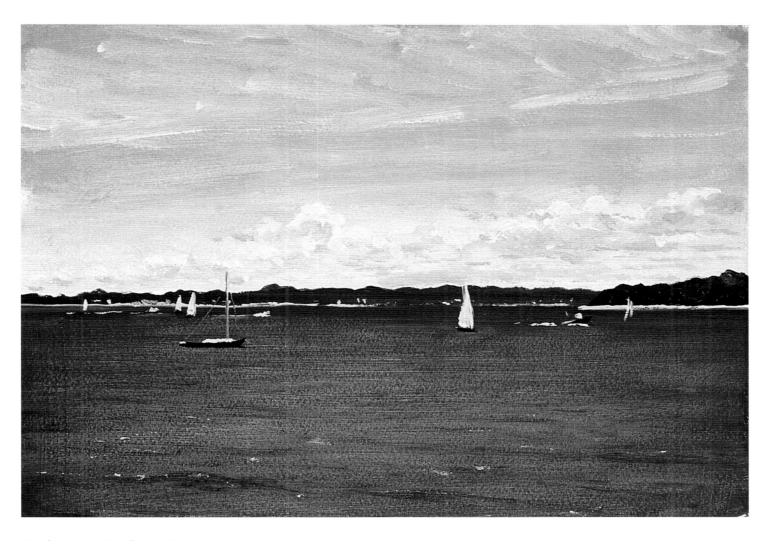

Dark Water, Gardiner's Bay

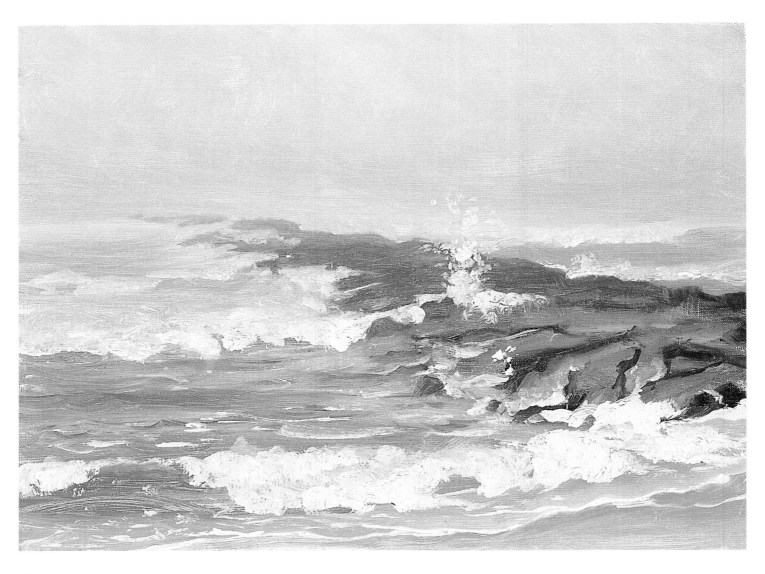

First Jetty, Georgica

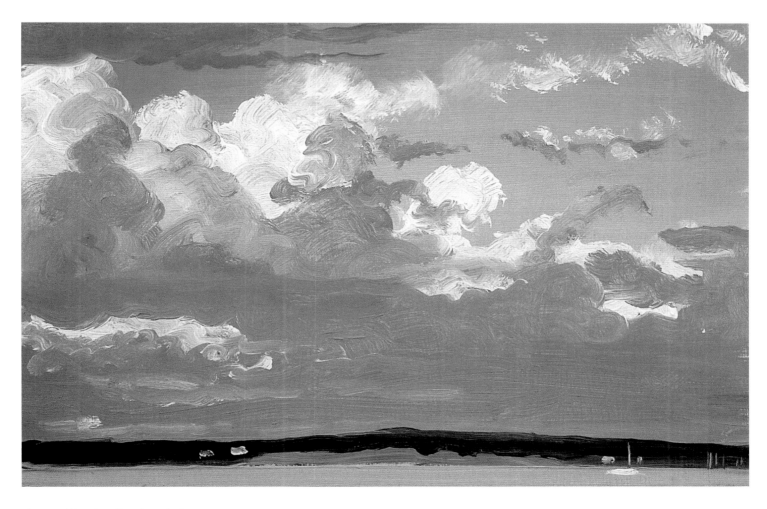

Storm Clouds, Gardiner's Bay

OVERLEAF:
Passing Storm, Three Mile Harbor

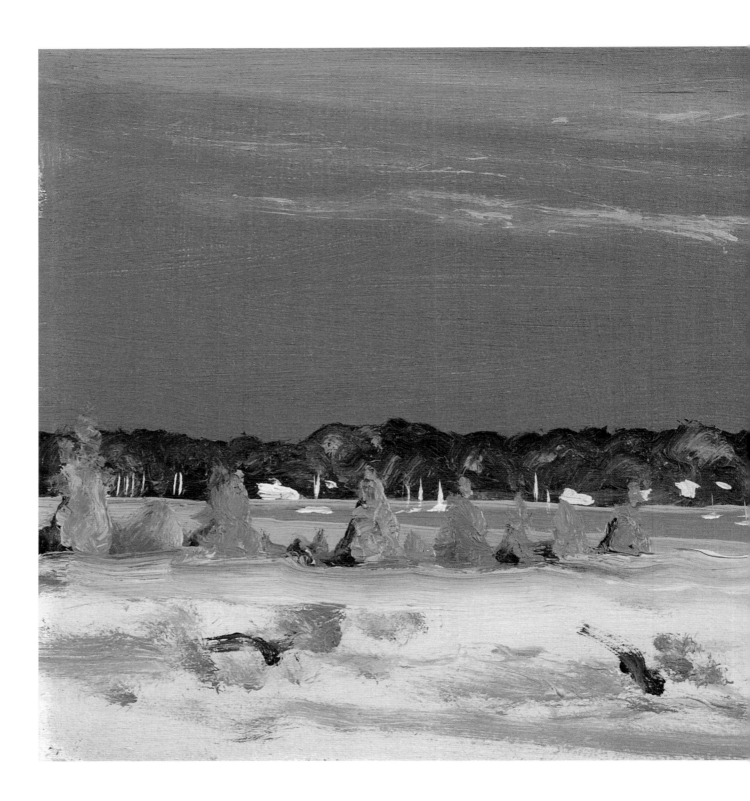

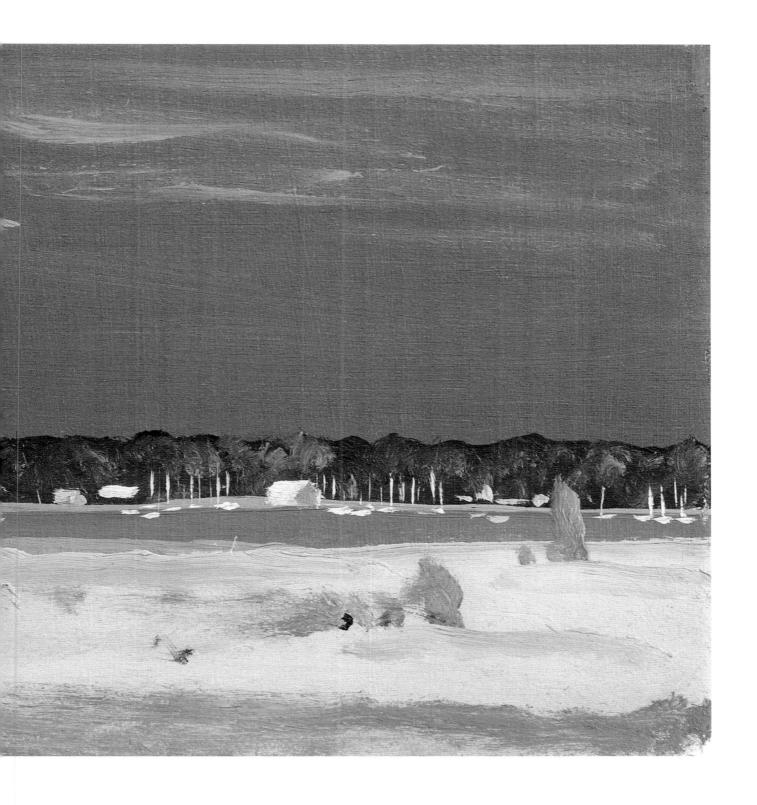

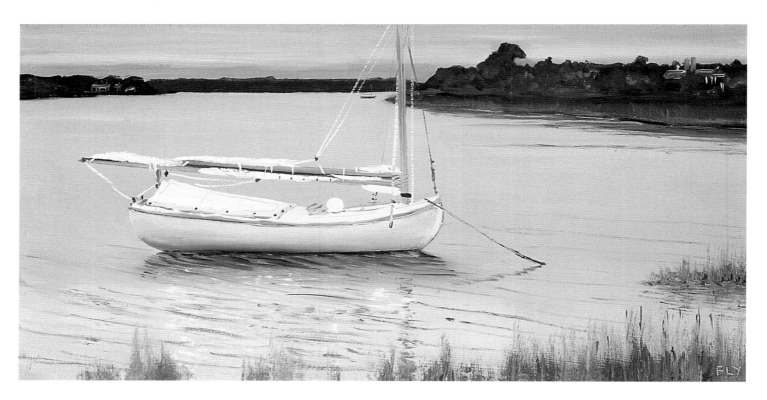

"Fly," Georgica Pond

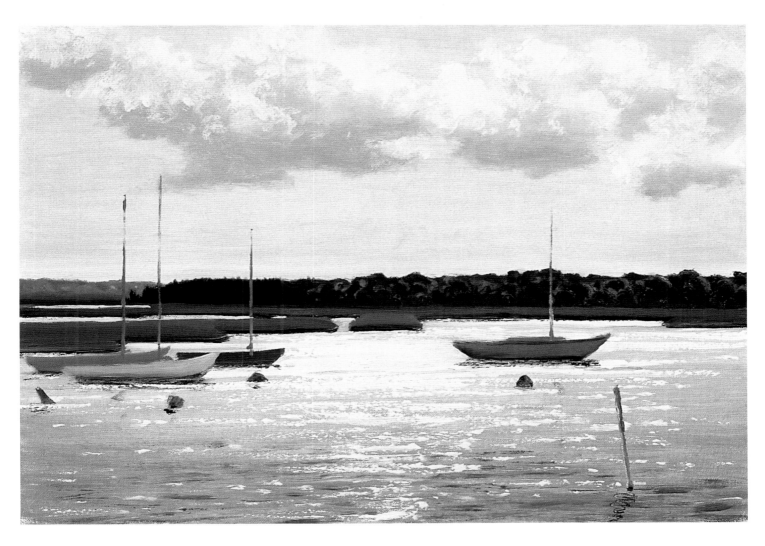

Sailboats, Accabonac Harbor

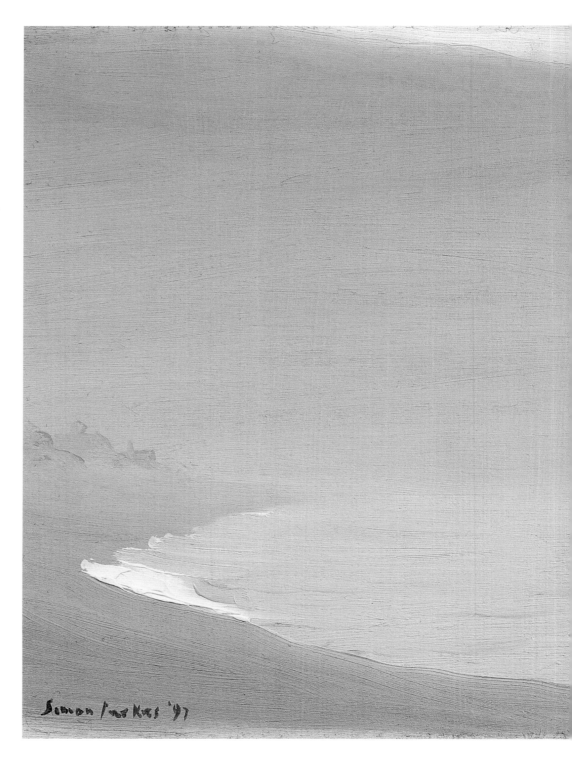

Sunrise, Georgica Beach

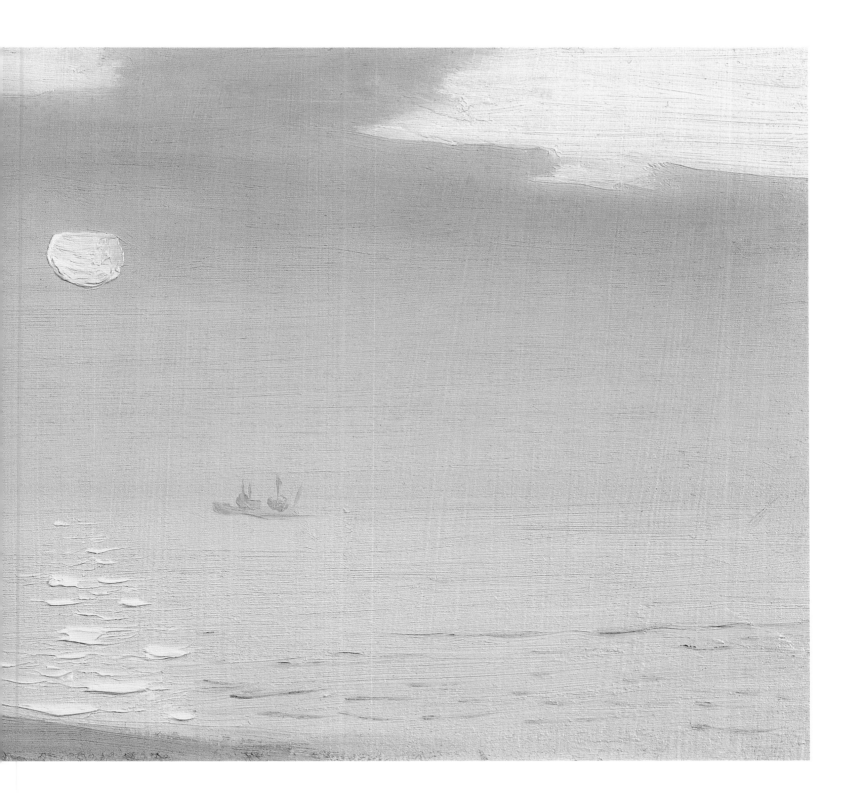

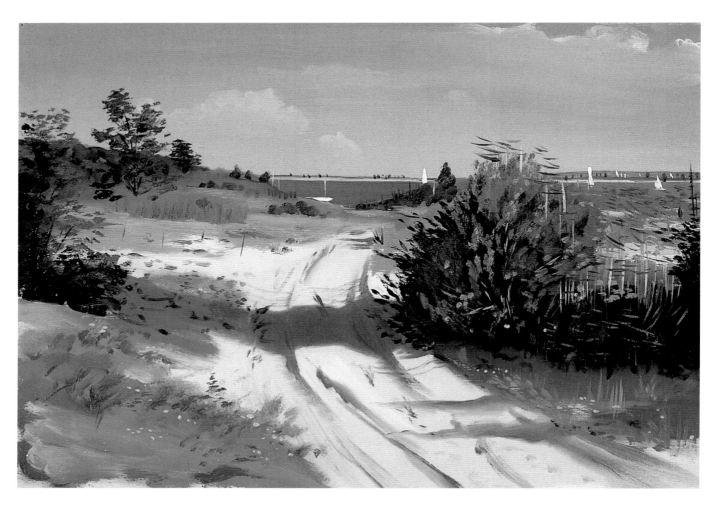

Sand Track, Gardiner's Bay

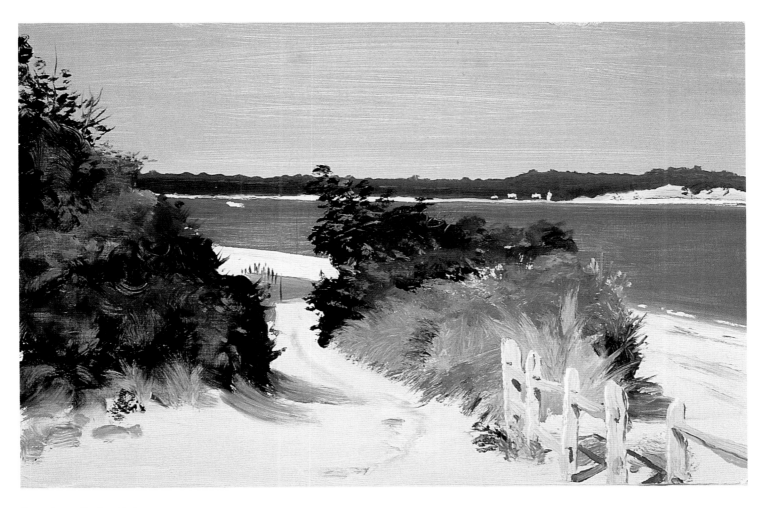

Beach at Cedar Point

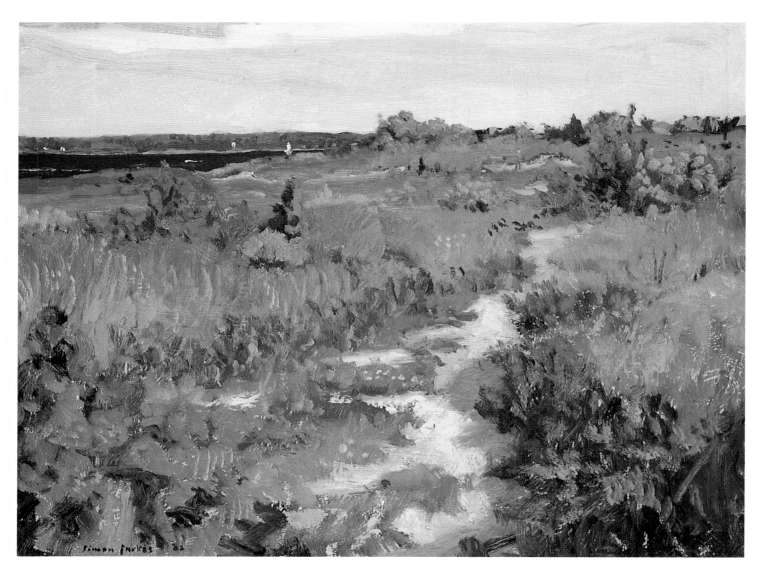

Autumn, Lazy Point

OPPOSITE: *Path to Long Lane*

OVERLEAF: *The Elizabeth Islands, Sunset*

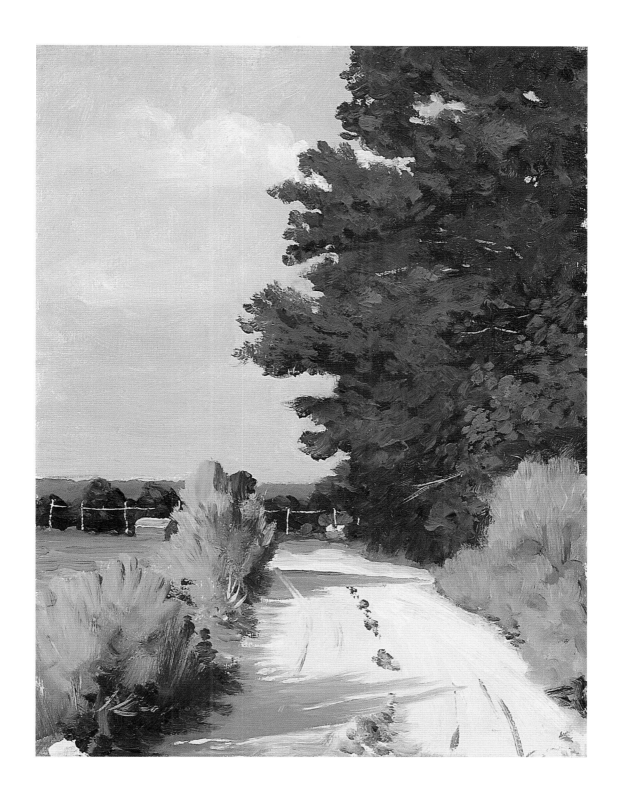

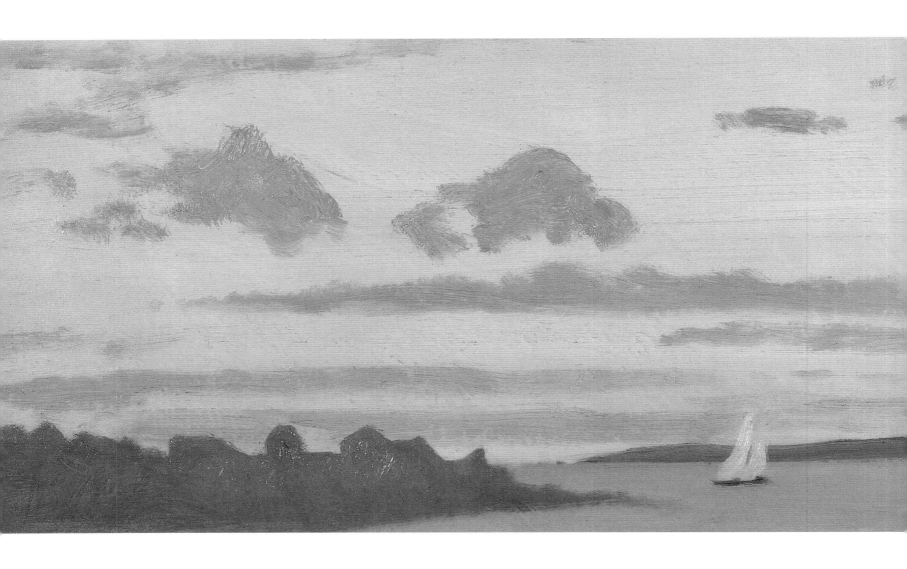

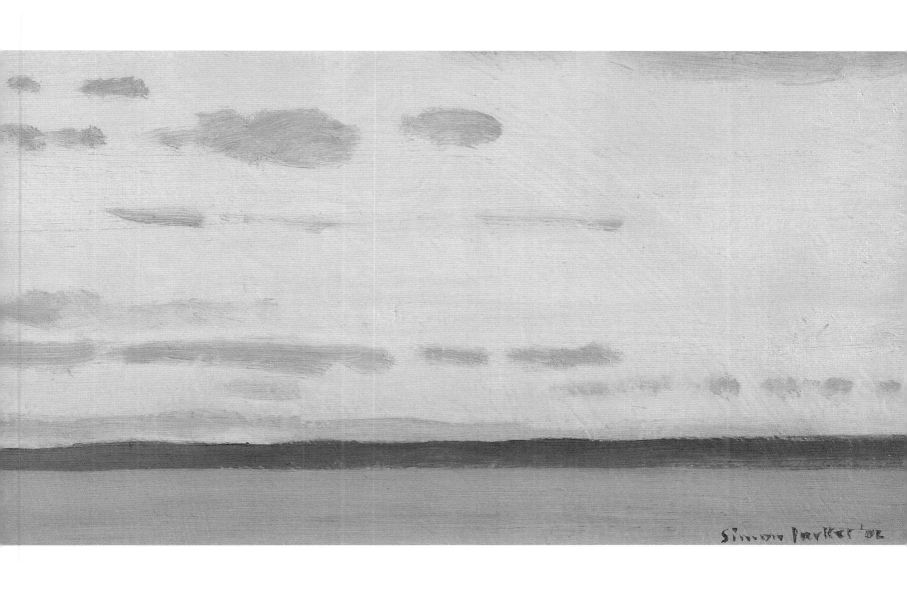

New England

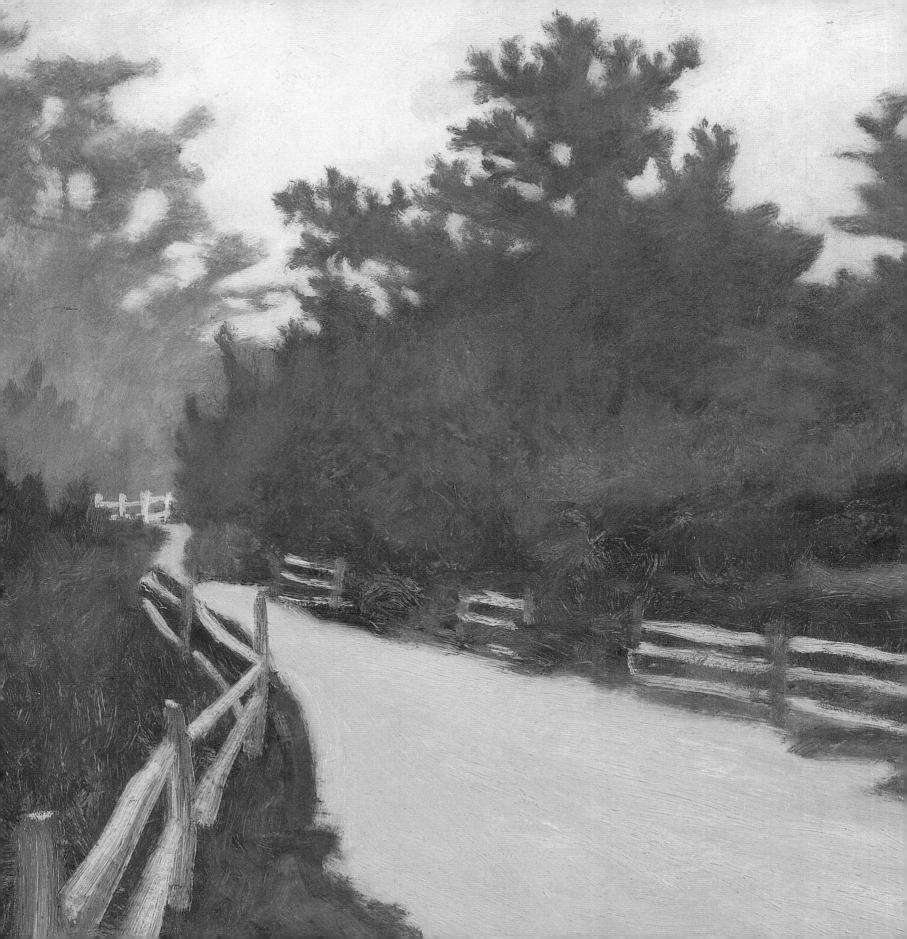

Massachusetts

A windswept crook of land, Cape Cod takes its name from the plentiful schools of cod that swim in its surrounding ocean currents. Provincetown, at its northern finger, is the sandy position that welcomed the first pilgrims in 1620; to the southeast, at the elbow of the cape, is Chatham. Incorporated in 1712, the community is sheltered from the open water by barrier beaches, harbors, estuaries, dunes, and saltwater ponds. A quiet habitat populated year-round by hardworking fishermen, it is a place whose population grows substantially in summer. However, visitors arriving to feel hot sand under bare toes do so discreetly. It is a resort where life seems to whisper.

Martha's Vineyard and Nantucket, islands roughly fifteen and twenty-five miles, respectively, to the south and east of Cape Cod, are also Massachusetts retreats where summer days are blazed into memory. Their low-lying lands once inhabited by Indians were settled in 1642 and in 1659. During the late 1700s, whaling became a prosperous New England activity and these islands, along with Cape Cod to the north and Long Island to the south, were at the heart of the industry. Stalwart sailors, including many experienced Indians, toiled on the open waters while industrialists on shore amassed great fortunes through associated trades at local shipyards, sail lofts, cooperages, chandleries, and oil refineries. Sperm whales were hunted for their high-quality oil, which produced bright illumination and clean

Madaket in the Fog

93

lubrication. Other by-products included spermaceti for candles, ambergris for perfume, whalebone, and whale's teeth. The eventual demise of the whaling business in the mid-1800s depleted the solvency of Nantucket, Martha's Vineyard, Cape Cod, and other profitable harbors along the New England coastline. As the tide shifted, idle resorts gradually replaced the commercial ports. Beyond the wharves, the surrounding plains of Cape Cod and its offshore islands featured lakes, pasture, cranberry bogs, wild roses, and expanses of sandy coastline that attracted artists and vacationers in abundance.

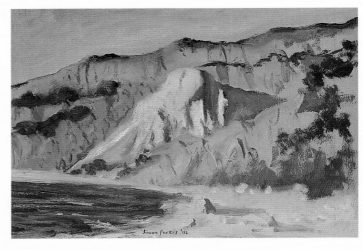

Cliffs at Gay Head

Simon Parkes frequents this triangle of Massachusetts regularly and paints all aspects of its summer life. In Chatham, where daily routines unfold quietly, he is fond of depicting muddy creeks, fishing boats, and sea-slapped docks whose posts lurch into the harbor at disorderly angles (pp. 108–09). In late September, a favorite time of year for him to visit, a crisp evening sky glowing pink and casting long shadows on a tip of land reminds him to work quickly (p. 116–17). "Being in a rush, I can go nuts trying to put it all in perspective. There is great discipline involved and I must remember to focus, to point and shoot while the light is still good," he says. "Along with a stained sky comes a rush of adrenaline."

Martha's Vineyard, shaped like a pork chop, covers an area of approximately one hundred square miles (about twice the size of neighboring Nantucket). The island was originally covered in lush grapevines and parts of it are densely timbered with oak and pine. A sense of canopied protection gives it a secluded feeling and indigenous forests shrouded in mist can seem eerie. Parkes refers to the island as "woody and weird" and is often found lurking in unexpected or neglected places. A painting of a weathered shingle house partially obscured by trees is a telltale composition. Shadows in the foreground suggest he has edged to a woodland periphery to peer at private property hidden within a sylvan glade (p. 97). The island's magnificent chalk cliffs at Gay Head are another of his favorite out-of-the-way spots with pictorial clout (above). Facing southwest at the edge of the sea, these cliffs are suffused with an apricot glow at sunset.

Nantucket, a sandy pancake by comparison, is situated a dozen miles to the east across Muskeget Channel. On clear days, limpid blue skies and broad plains stretch for miles. Thousands of grazing sheep once dotted the gently rolling moors now speckled with daisies, scrub oak, and purplish pink heather. Pitch pine trees stunted by the wind rise above open fields of goldenrod, wild aster, yarrow, sheep sorrel, thistles, and Queen Anne's lace. A part of Nantucket's open land is deeded as recreational commons. Dusty paths crisscrossing Tupancy Links, a former golf course, suggest a barren heath in another country (p. 96). "Nantucket can be as flat and austere as parts of Scotland," Parkes says admiringly. When an island sky hangs hazily over the cliffs, the painter typically fuzzes out the horizon and concentrates on foreground and middle distance (p. 103). In another Nantucket view, shrubby foliage and fog swallow up a sandy road in the forefront and deliver an immediately engrossing composition (p. 92).

Affectionately dubbed the "Gray Lady" by salt-of-the-earth residents accustomed to an enveloping mist, Nantucket is subject to long spells of gloom and overcast weather. However, a dreary day never fails to hold fascination for Parkes as long as an intriguing sense of light prevails. His artistic quarry triumphs in multiple circumstances, and Nantucket's climate, sea, and sky conjure fundamental emotions. When there is no flattery to be fed to the landscape, the solitary artist is perfectly at peace.

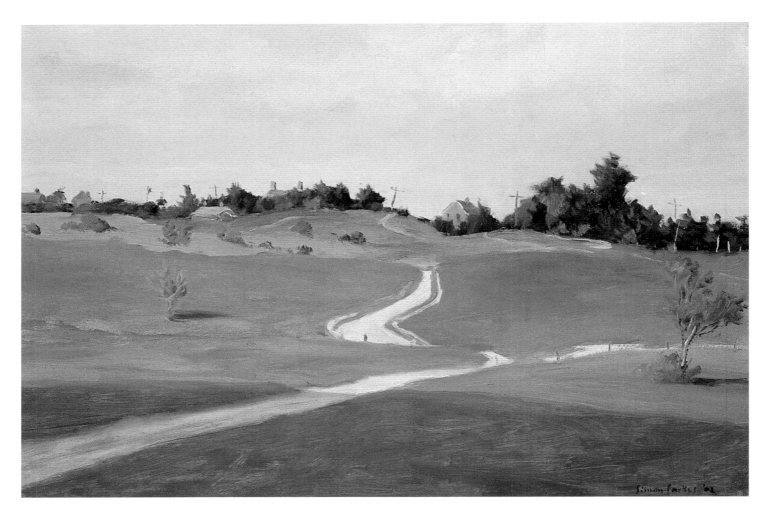

Tupancy Links, Nantucket

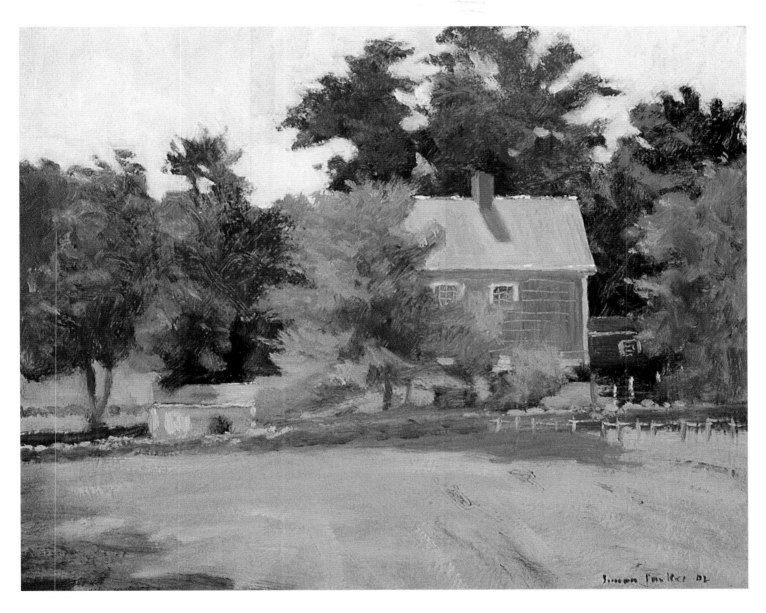

Farmhouse, Martha's Vineyard

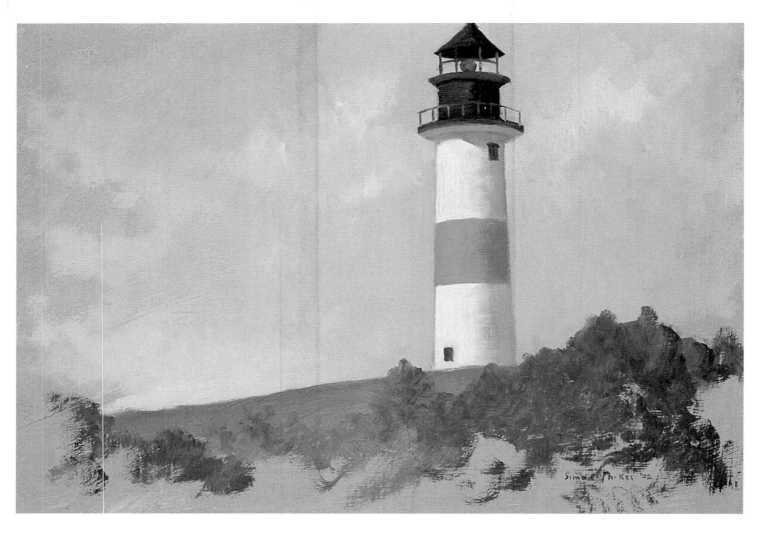

Sankaty Lighthouse, Nantucket

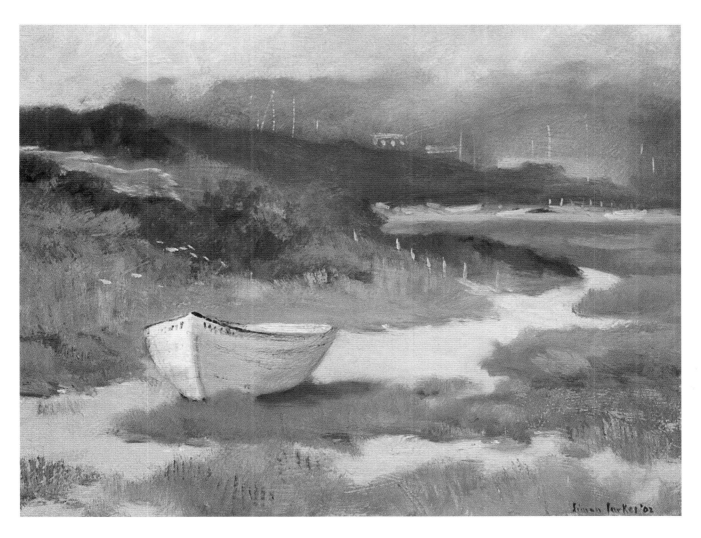

Rising Fog, Menemsha

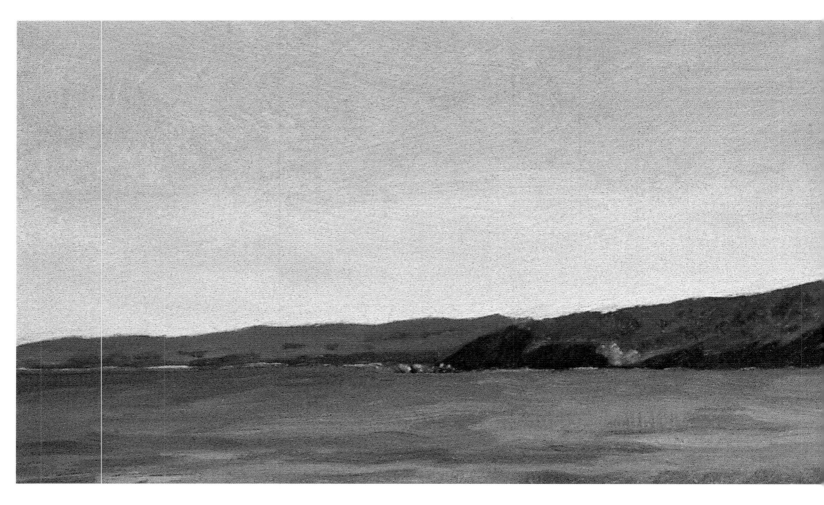

Looking East from Menemsha

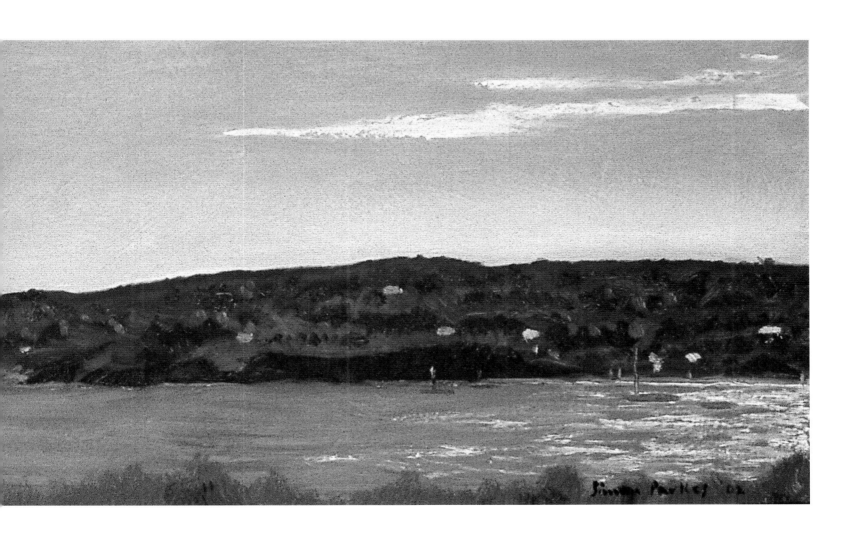

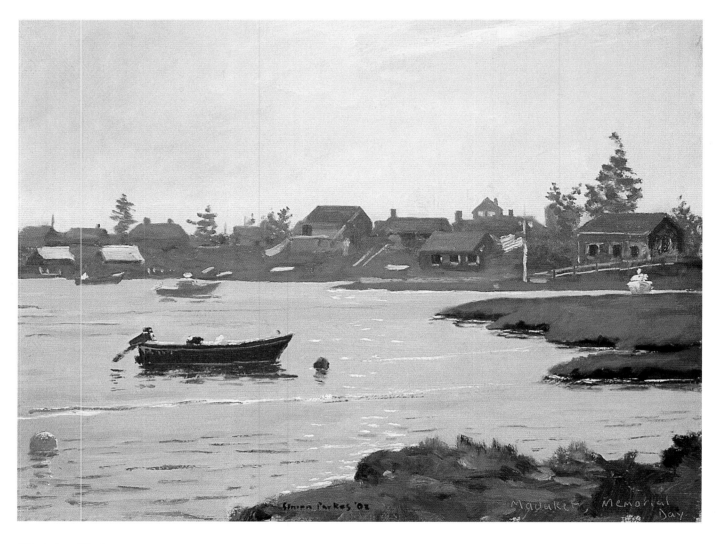

Madaket Harbor

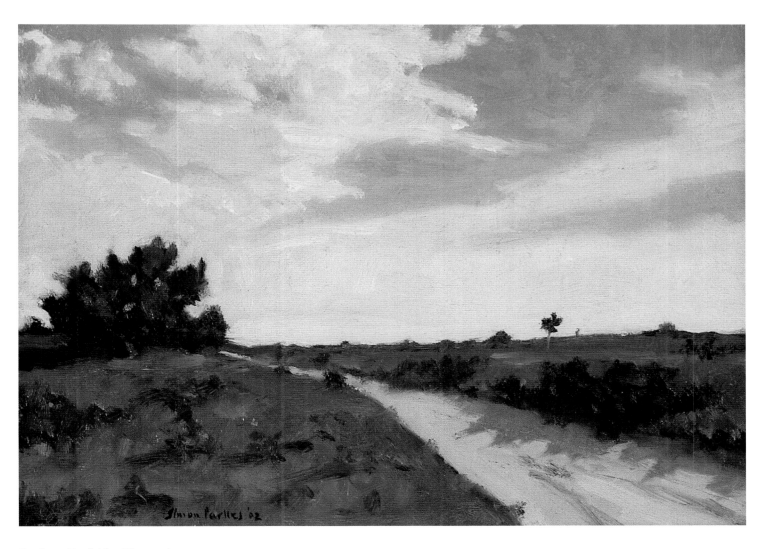

Path to Surfside, Nantucket

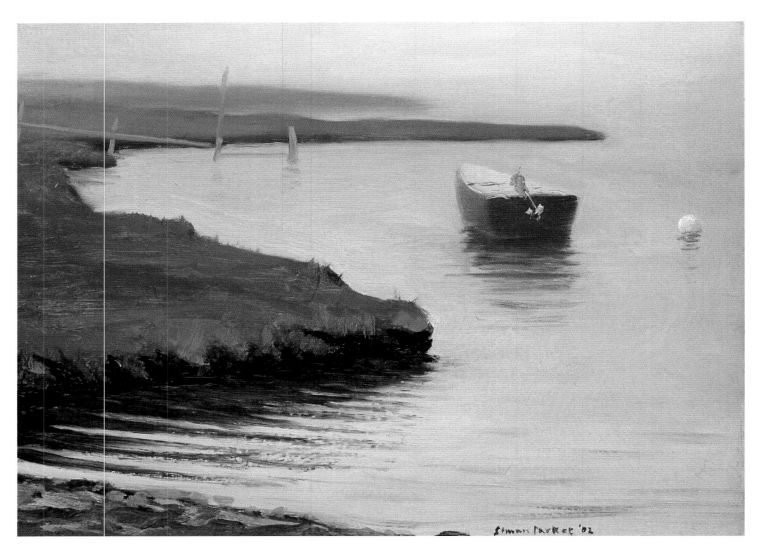

Foggy Afternoon, Madaket

OPPOSITE: *House in Siasconset*

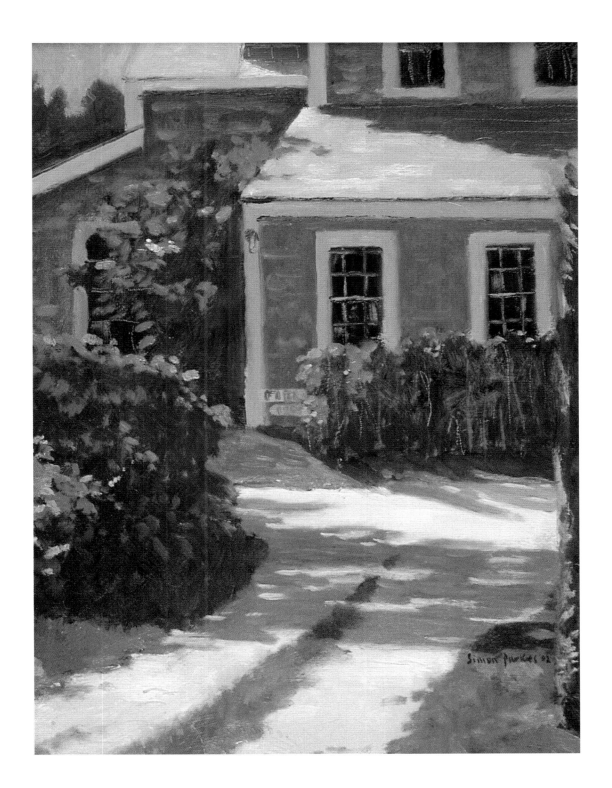

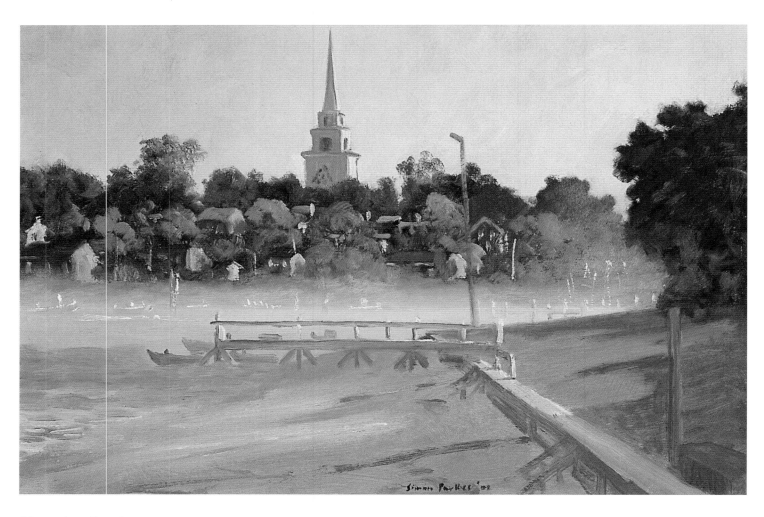

Nantucket, Evening

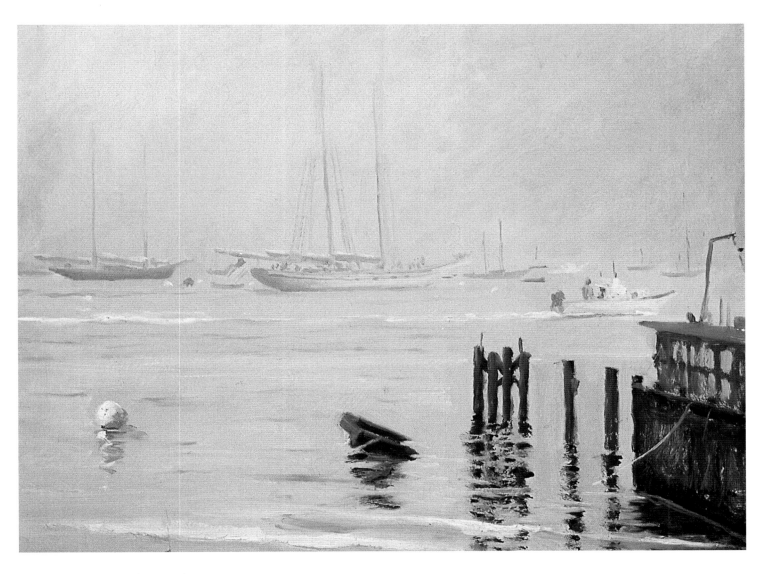

Heavy Fog, Nantucket Harbor

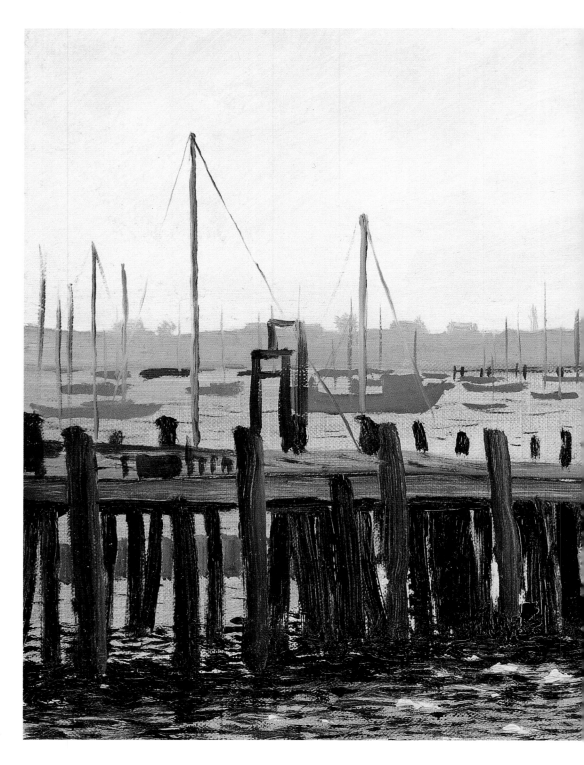

Chatham Harbor

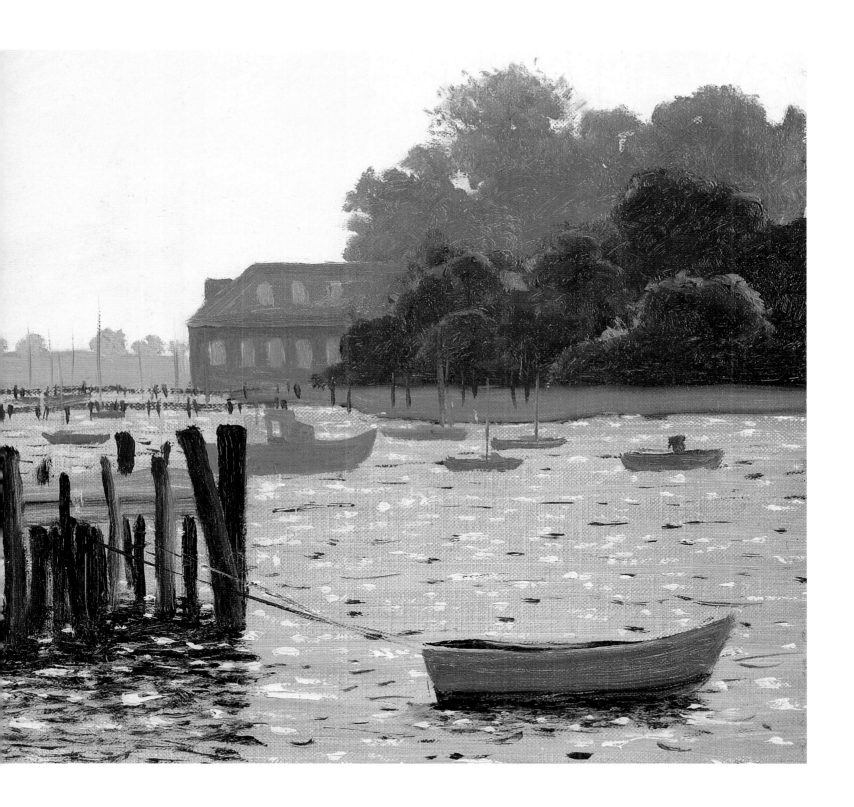

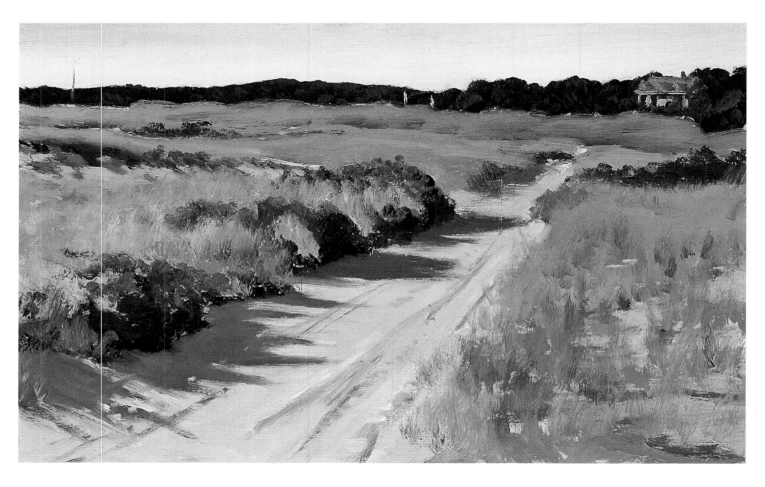

Hardings Beach, Chatham

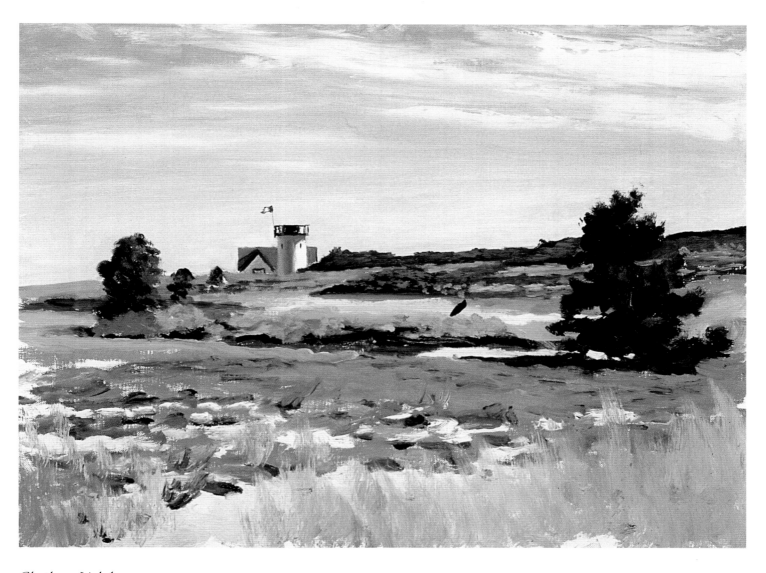

Chatham Lighthouse

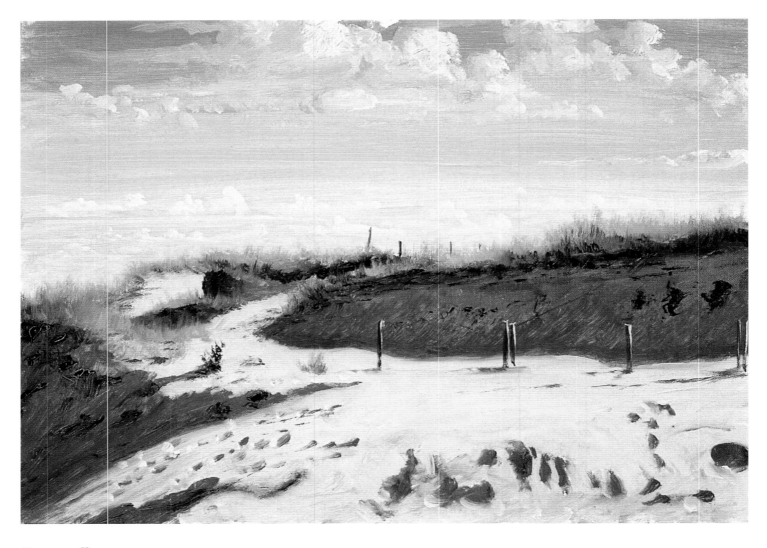

Dunes at Truro

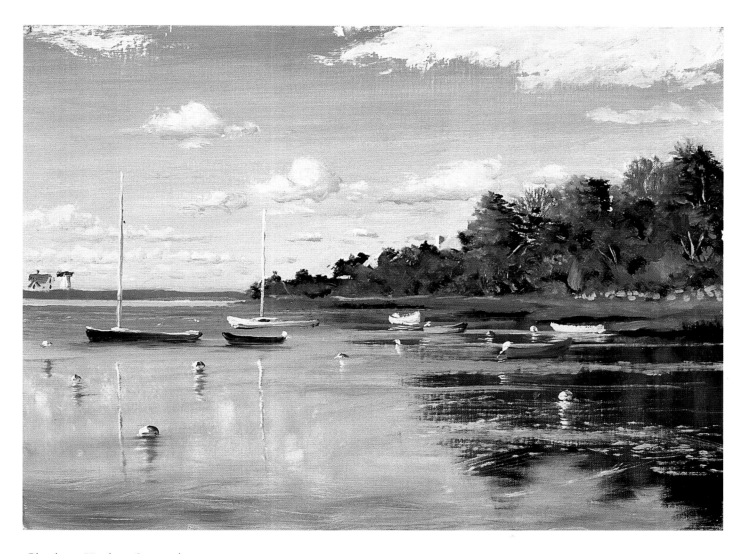

Chatham Harbor, September

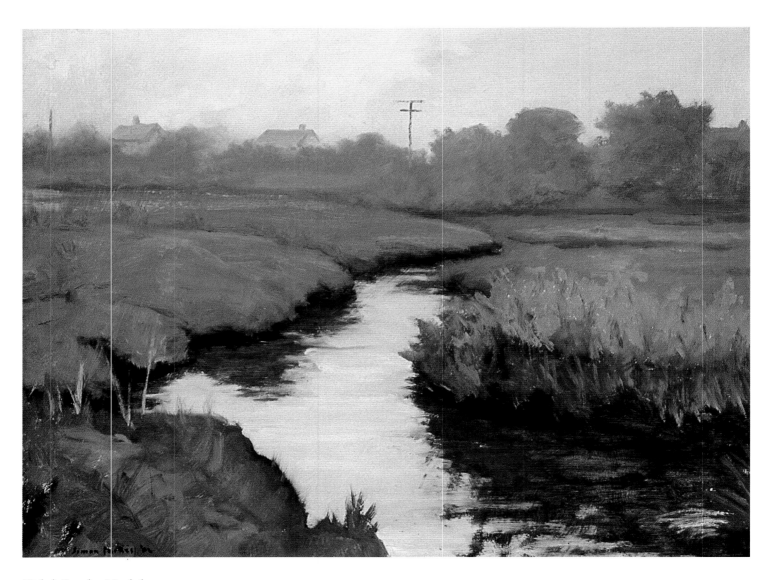

Tidal Creek, Madaket

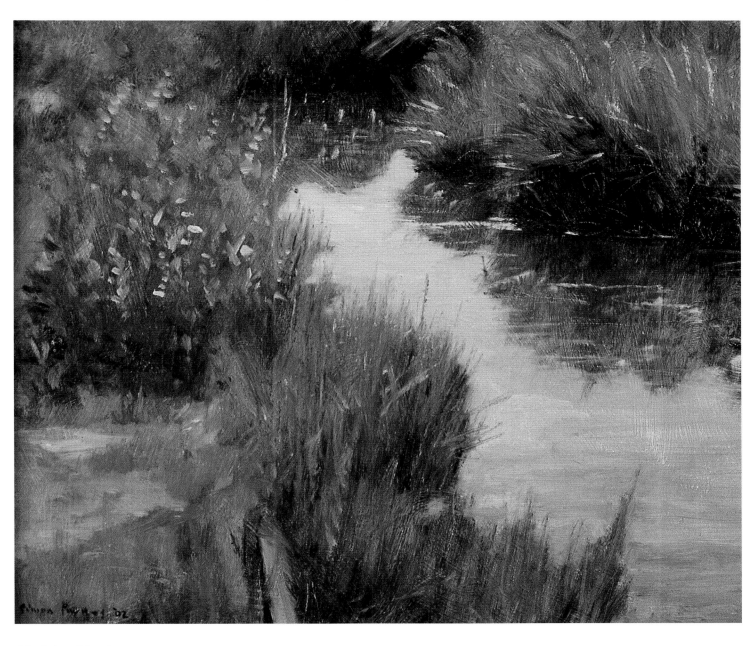

Madaket Marshes

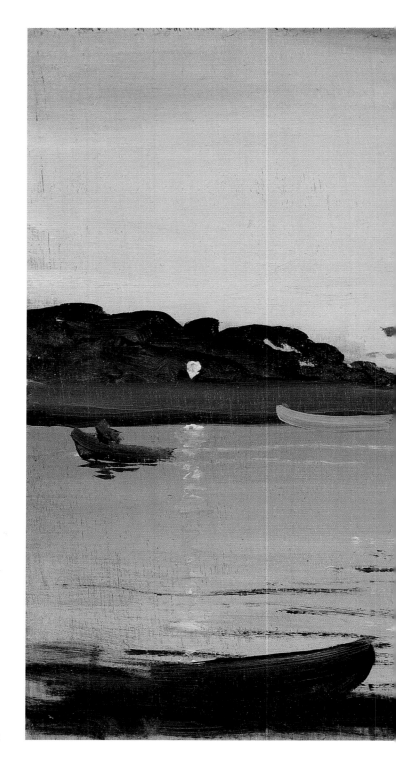

Dusk, Chatham

116

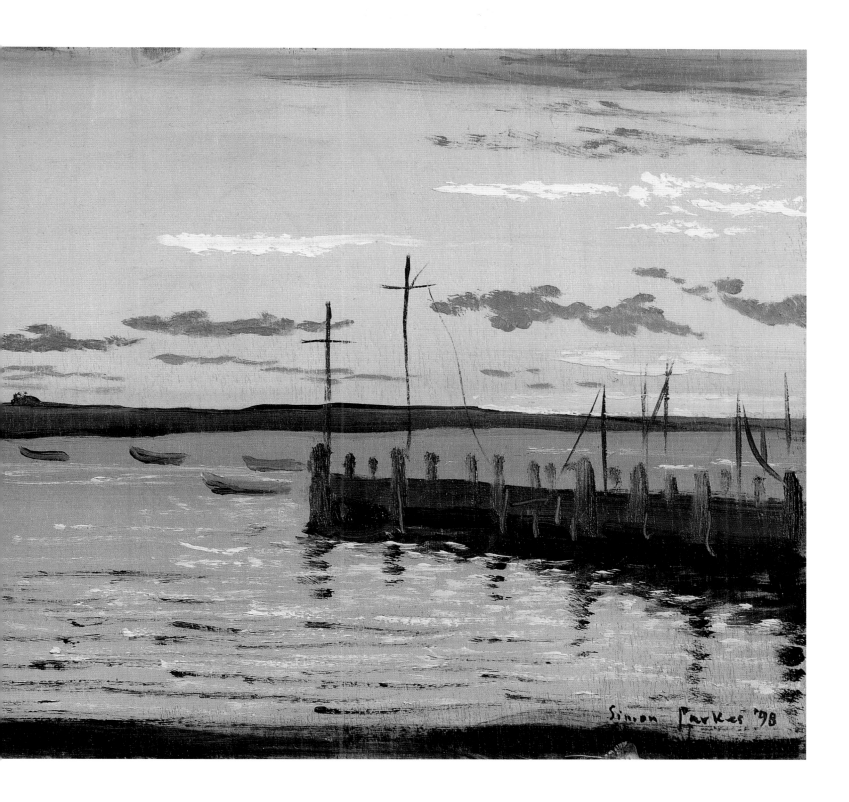

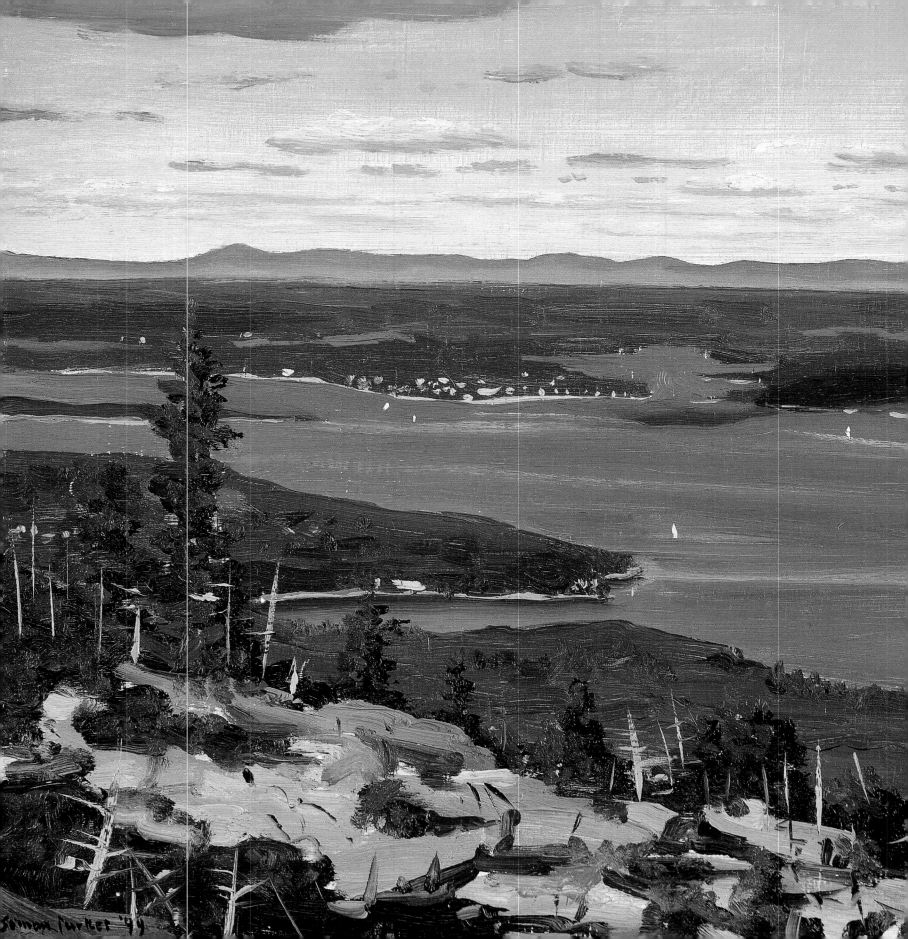

Maine

The Gulf of Maine with its serrated shoreline has seized the interest of artists, explorers, and vacationers for centuries. Interspersed with steep summits and craggy notches that plunge between inlets and bays, a convoluted coast extends in a northeasterly crescent from New Hampshire to New Brunswick, Canada. Offshore, thousands of islands with distinctive names such as Cow, Crab, Crow, Goose, and Moose bear witness to the birds and animals that frequent them. They compose a panorama of irregular shapes and sizes, the remnants of volcanic eruptions sculpted by fire, ice, wind, and a crashing sea. Indian relics including arrowheads and shell heaps still dot Maine's gray cobble beaches, while its inland terrain is heavily wooded with hemlock, fir, white pine, and birch.

The celebrated French explorer Samuel de Champlain first perused the Maine frontier in the autumn of 1604. Sailing from Schoodic Point across Frenchman Bay on September 6, he named the naked mountaintops he saw before him "L'isle des Monts-deserts" (i.e., the island of bare mountains).[1] Christened for its bald appearance, Mount Desert Island and its sculpted pink granite peaks, valleys, lakes, and fjord were formed fourteen thousand years ago when glaciers melted at the end of the most recent ice age. Its 1,532-foot crest, Cadillac Mountain, is the highest point along the eastern seaboard. The rise can be spotted from sixty miles away and its summit commands a sweeping view of

View from Cadillac Mountain, Mount Desert

Maine's coastal promontories. Viewed from the mainland across Frenchman Bay, the cleft profile of the island's majestic silhouette undulates against the sky in deepening shades of teal, azure, and indigo, depending upon the perspective and time of day. In the words of the distinguished writer Samuel Eliot Morison, "The hills of Mount Desert arise like blue bubbles from the sea."[2]

Ever since the founding figures of American landscape painting, including Thomas Doughty, Thomas Cole, and Frederic Edwin Church, ventured to Maine in the mid-1800s, its scoured turrets, spruce-hooded hilltops, and mossy forests have commanded artists' affection. Childe Hassam frequented Appledore Island off the southern coast; the geological grandeur and raw beauty of Monhegan was a mecca for George Bellows, Edward Hopper, and Jamie Wyeth; and countless artists, among them William Stanley Haseltine, Marsden Hartley, and John Marin, have painted the heaped-up boulders, glacial debris, and inviting harbors of Mount Desert Island and its environs.

Simon Parkes is a relative newcomer to Maine. He made his first painting trip to the state in the late 1990s at the invitation of a friend, the art dealer W. Mark Brady, who has summered at Hancock Point for many years. Situated at the tip of an island peninsula that juts into Frenchman Bay, the idyllic summer colony enjoys unsurpassed views that embrace Sorrento, Schooner Head, Ironbound, the Porcupines, Thrumpcap, and Bar and Mount Desert Islands. Once a lively harbor for sailing vessels, the commerce in and around these hamlets has declined. By the late 1880s as many as thirty thousand summer visitors from Philadelphia, New York City, and Boston would arrive via Maine Central Railroad at Mount Desert Ferry.[3] From there, regular steamboat service shuttled passengers eight miles across Frenchman Bay to Bar Harbor, a township known as Eden until 1918.[4] The crossing was a holiday gateway for notable financiers named Rockefeller, Vanderbilt, Biddle, Morgan, Pulitzer, and Ford as well as Presidents Taft, Franklin Roosevelt, and Truman. Ferrying passengers provided local employment, and farmers from nearby settlements such as Hancock and Sullivan also profited by transporting their produce cheaply to markets in Bar Harbor. In the 1930s, however, the installation of a bridge connecting the mainland and Mount Desert curtailed steamer traffic except for boats arriving from afar. Mount Desert Ferry is now a sleepy dock and its surrounding shores are largely reclaimed by forest.

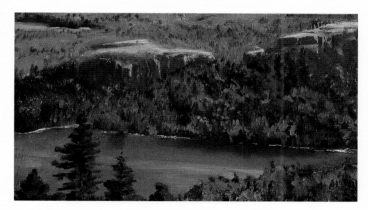

Jordan Pond

Hancock Point, a community that never succumbed to ruinous gentrification, is a relatively slow-paced and humble place as well. A quiet dispersal of farms and open fields at either side of a narrow road leads to a handful of houses, wooden piers, and an occasional weir at water's edge. Ringed by a greenbelt of pitch pine and pointy firs, the coastline is often buffeted by choppy waters and variable weather. The area's unpredictable forecast appeals to Parkes. Under sinister-looking skies, the artist likes to paint at sea level, where a glossy pelt of algae and bladder wrack, a species of indigenous seaweed that adheres to barnacle-encrusted rock, swishes with the tide (pp. 126–27). Farther out in the bay, lobster boats spew and chug between bundles of buoys marking a string of underwater traps, gulls dive in their wake, and an occasional wooden sloop threads its way between distant islands (p. 129).

Facing east toward Sorrento and Schoodic Mountain, there is a sheltered harbor where a gray-painted wooden quay raised on massive, rectangular granite pilings extends a horizontal ramp over icy blue depths (p. 124). At midday, when the wind is up, the spot is a focal point of Hancock Point's short summer season. The walkway leads to a floating mooring where a dozen scruffy rowboats tremble and bob waiting to be launched toward sailboats safely anchored in deeper water (pp. 130–31). The relatively deserted atmosphere is a beacon of inspiration for Parkes. Most mornings and evenings, a loon's lonely cry and the metallic clink of boat tackle are his hollow-sounding companions. "I like it here because there is nothing going on," he says, "yet the bay is full of natural and original compositions to paint."

Parkes has clambered to the heights of Mount Desert Island for a bird's-eye view back toward the mainland. High aloft the mountaintop a boundless perspective is accentuated. The furrowed coastline resembles a crumpled hand slithering into water under the pall of a hazy cloud (p. 118). He also has painted Mount Desert's interior lakes and ponds, tucked within the gentle rise of the island's heavily wooded green blanket (above). "As I am not overly fond of painting dense forests," he admits, "I tend to avoid roaming Acadia National Park, but I do like the funny shape of Cadillac Mountain poking at the clouds."

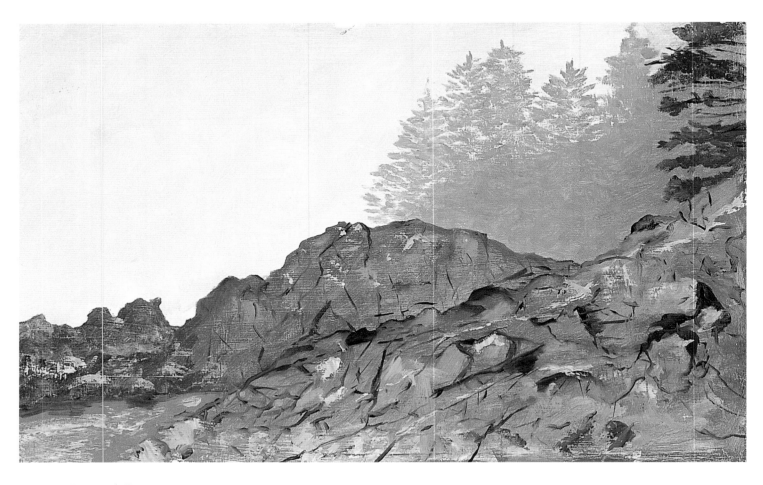

Mist on Hancock Point

OPPOSITE: *Gray Day, Hancock Point*

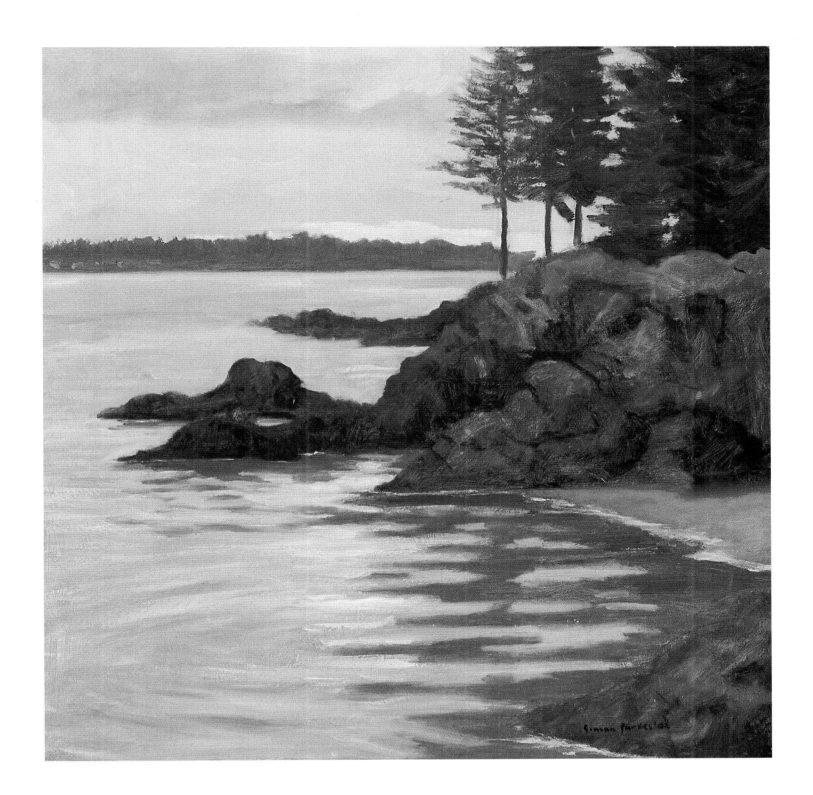

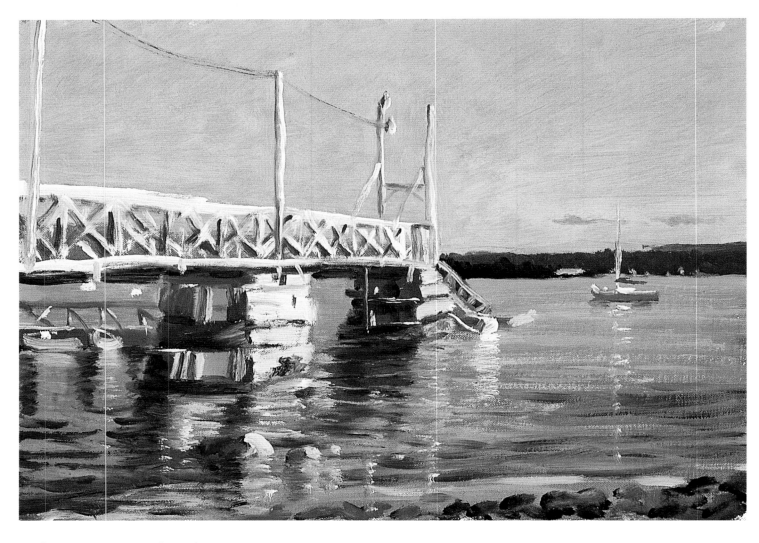

Early Morning, Hancock Dock

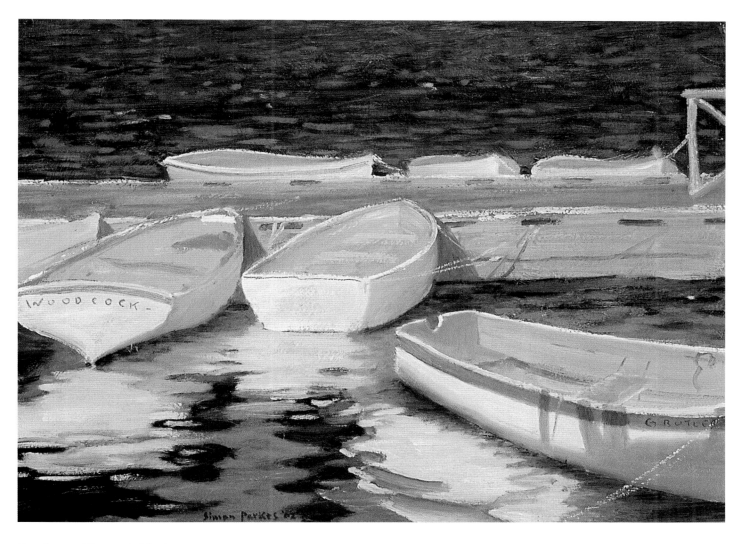

Rowboats, Hancock Harbor

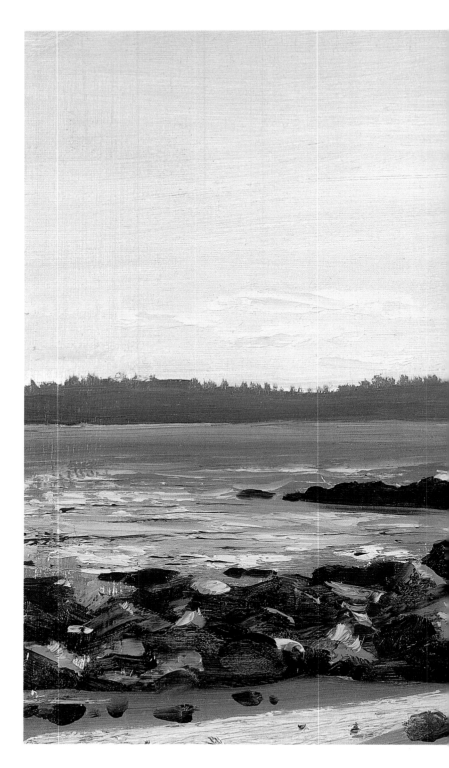

Last Light, Hancock Point

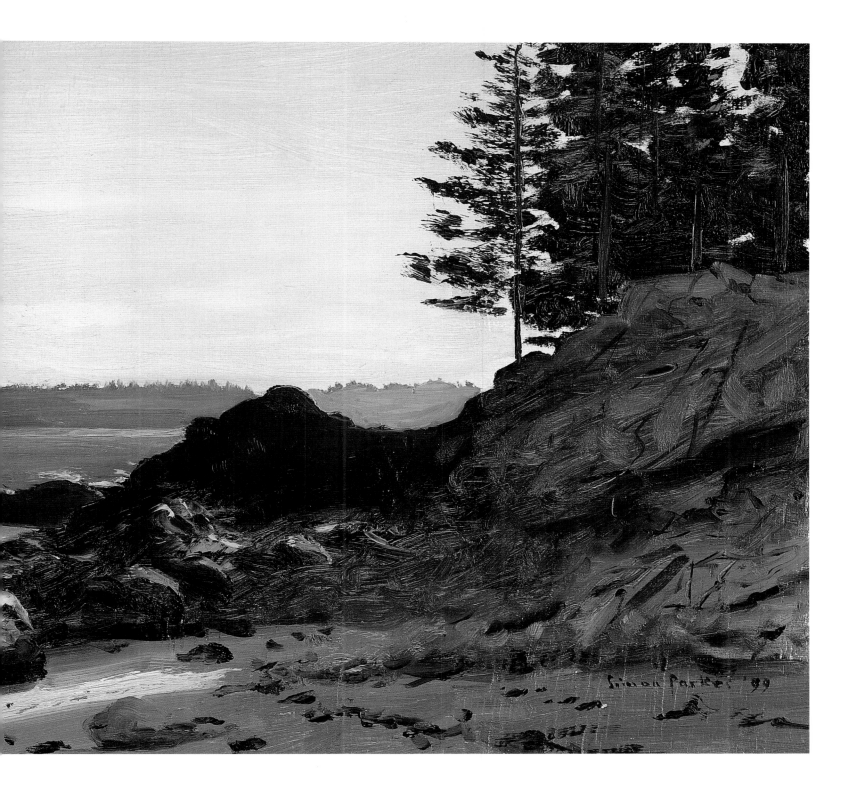

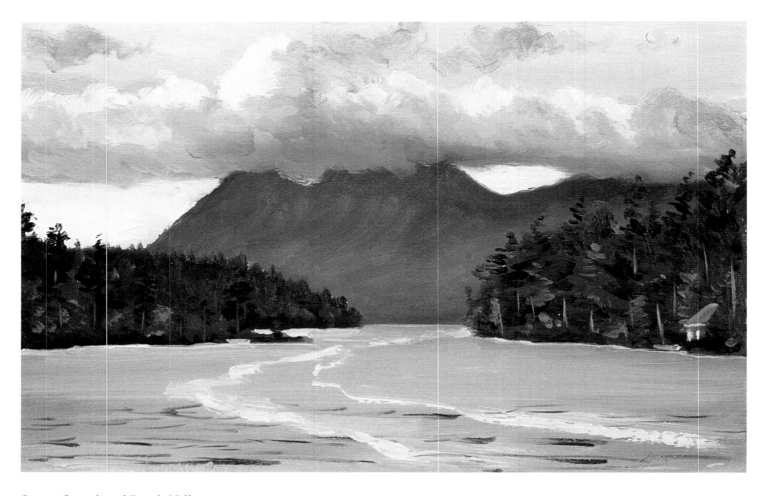

Somes Sound and Beech Hill

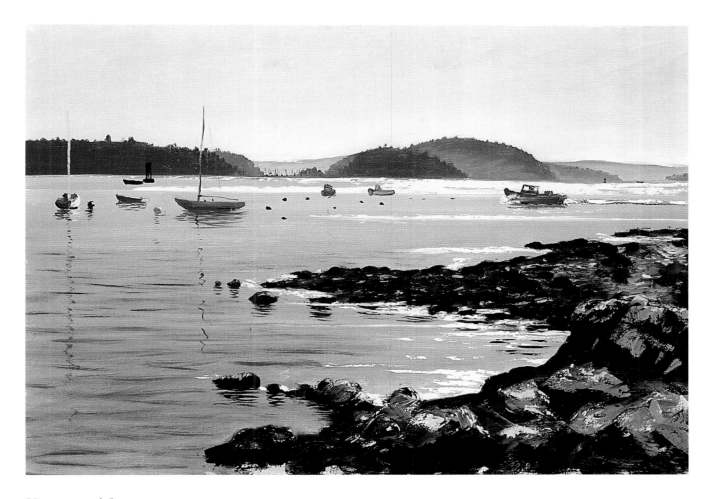

View toward Sorrento

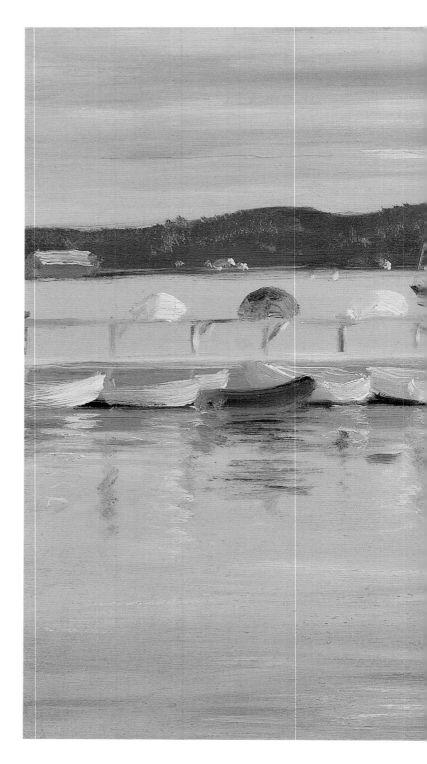

Silver Light, Hancock Harbor

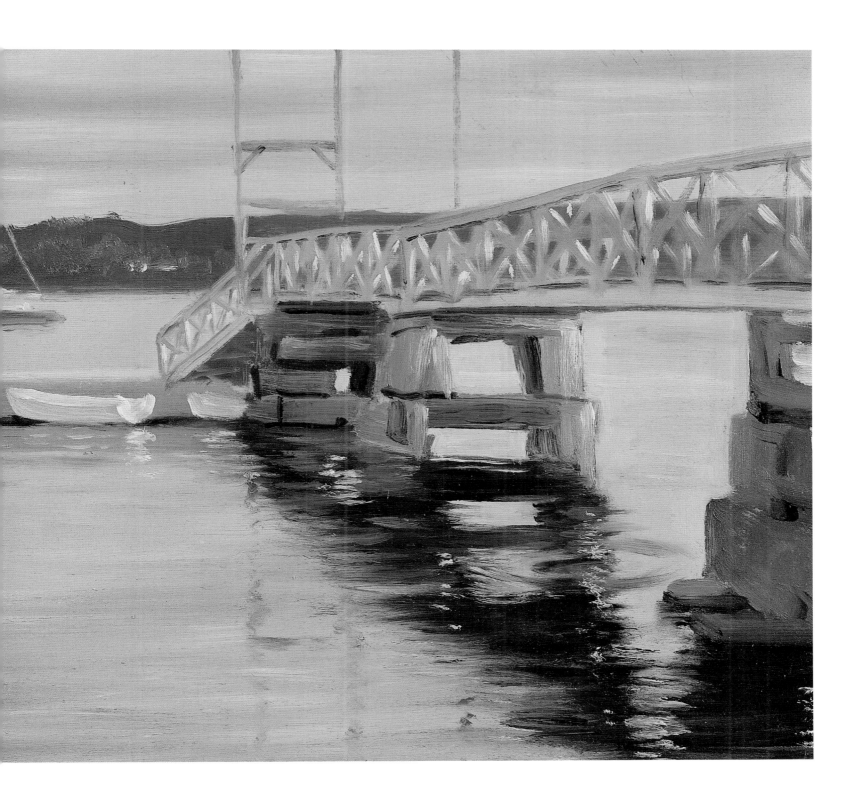

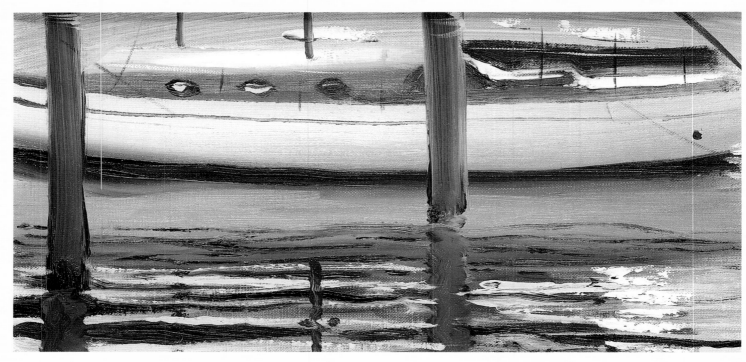

Three Mile Harbor

Notes

Introduction

1. John Wilmerding, *The Artist's Mount Desert: American Painters on the Maine Coast* (Princeton, N.J.: Princeton University Press, 1994), p. 152.

2. Hilton Kramer, "John Constable Liked Painting Landscape, but Looked to Sky," *New York Observer,* 24 May 2004, p. 1.

3. Christopher Riopelle and Xavier Bray, *A Brush with Nature: The Gere Collection of Landscape Oil Sketches*, exh. cat. (London: The National Gallery, 1999), p. 52.

4. Kramer, "John Constable Liked Painting Landscape," p. 1.

5. Florian Härb and Tim Warner-Johnson, *Out into Nature,* exh. cat. (London: Colnaghi, 2003), p. 9.

6. Ibid., p. 5.

7. Freda Constable, "The Man of Clouds," in *Constable's Skies*, in exh. cat. (New York: Salander-O'Reilly Galleries, 2004), p. 14.

8. Härb and Warner-Johnson, *Out into Nature,* p. 3.

9. Jeremy Strick, "Jean-Baptiste-Camille Corot," in *In the Light of Italy: Corot and Early Open-Air Painting,* exh. cat. (Washington, D.C./New Haven: The National Gallery of Art and Yale University Press, 1996), p. 218.

10. Peter Galassi, "A Tribute to J. A. Gere," in *In the Light of Italy: Corot and Early Open-Air Painting,* p. 25.

Eastern Long Island

1. K. L. Bryant, Jr., *William Merritt Chase: A Genteel Bohemian* (Columbia, Mo.: University of Missouri Press, 1991), p. 157.

2. D. S. Atkinson and Nicolai D. Cikovsky, Jr., *William Merritt Chase: Summers at Shinnecock* (Washington, D.C.: National Gallery of Art, 1987), p. 25.

Maine

1. Samuel Eliot Morison, *The Story of Mount Desert Island* (Boston: Little, Brown , 1960), p. 9.

2. Ibid., p. 3.

3. Sesquicentennial Committee of the Town of Hancock, Maine, *A History of the Town of Hancock 1828–1978* (Ellsworth, Maine: Downeast Graphics, 1978), p. 68.

4. Morison, *The Story of Mount Desert Island,* Appendix II, p. 77.

Bibliography

Atkinson, D. S, and Nicolai D. Cikovsky, Jr. *William Merritt Chase: Summers at Shinnecock,* Washington, D.C.: National Gallery of Art, 1987.

Bancroft, Frederic, ed. *Constable's Skies*, exh. cat., New York: Salander-O'Reilly Galleries, 2004.

Bryant, K. L., Jr. *William Merritt Chase: A Genteel Bohemian*, Columbia, Mo.: University of Missouri Press, 1991.

Colt, George Howe. *The Big House: A Century in the Life of an American Summer Home,* New York: Scribner, 2003.

Conisbee, Philip et al. *In the Light of Italy: Corot and Early Open-Air Painting,* exh. cat., Washington, D.C./New Haven: The National Gallery of Art and Yale University Press, 1996.

Galassi, Peter. *Corot in Italy*, New Haven: Yale University Press, 1991.

Gill, Brendan. *Summer Places*, New York: Methuen, 1974.

Glueck, Grace. "Constable, A Painter for Whom a Cloudy Day Was a Welcome Opportunity," *New York Times,* 11 June 2004, sec. E, p. 39.

Härb, Florian, and Tim Warner-Johnson. *Out into Nature,* exh. cat., London: Colnaghi, 2003.

Helfrich, G. W., and Gladys O'Neil. *Lost Bar Harbor,* Camden, Maine: Down East Books, 1982.

Kelly, Frank et al. *American Masters from Bingham to Eakins: The John Wilmerding Collection,* exh. cat., Washington, D.C.: The National Gallery of Art, 2004.

Kimmelman, Michael. "Little Paintings with Big Visions," *New York Times,* 11 October 1996, sec. C, p. 1.

Kramer, Hilton. "John Constable Liked Painting Landscape, but Looked to Sky," *New York Observer,* 24 May 2004, p. 1.

Little, Carl. *Art of the Maine Islands*, Camden, Maine: Down East Books, 1997.

Miles, Mary. *Nantucket Gam*, Nantucket, Mass.: Faraway Publishing Group, a division of Educational Management Network, Inc., 1993.

Morison, Samuel Eliot. *The Story of Mount Desert Island,* Boston: Little, Brown, 1960.

Norton, Henry Franklin. *Martha's Vineyard*, Oak Bluffs, Mass.: Oak Bluffs Homemakers Club, 1979.

Pisano, Ronald G. *Long Island Landscape Painting 1820–1920*, Boston: Little, Brown, 1985.

Riopelle, Christopher, and Xavier Bray. *A Brush with Nature: The Gere Collection of Landscape Oil Sketches,* exh. cat., London: The National Gallery, 1999.

Russell, John. "To Be Young and Smitten with Roman Light," *New York Times,* 16 August 1996, sec. C, p. 13.

Sesquicentennial Committee of the Town of Hancock, Maine. *A History of the Town of Hancock 1828–1978,* Ellsworth, Maine: Downeast Graphics, 1978.

Siminoff, Elizabeth. *Frenchman's Bay,* Chester, Conn.: The Pequot Press, a publication of the Coleraine Press, Inc., 1973.

Wilmerding, John. *The Artist's Mount Desert: American Painters on the Maine Coast,* Princeton, N.J.: Princeton University Press, 1994.

Afterword Simon Parkes

I was always told that *plein air* painting began in the late eighteenth century, when Valenciennes worked from life in Italy, spawning many nineteenth-century painters, most notably Corot.

The Dutch landscape painters of the seventeenth century constantly worked outdoors to produce staggeringly beautiful and unequaled northern landscapes. Velázquez painted wonderful, simple views in Rome. Thomas Jones went to Italy in the 1780s and painted from his Roman rooftop and in the Mediterranean countryside. Obviously, a great deal of drawing occurred outside the studio, but a number of artists over these centuries painted *en plein air* as well. These immediate *plein air* paintings are timeless. They have no style exactly nor cultural influence. When an artist is outside, he works only from what is in front of him.

I don't think I have much imagination that I can use in my painting. I wish I could, but the most I can do is sometimes to see things slightly differently. I look for light and shadow, good reflections in water, interesting skies, and not too much color. I try to

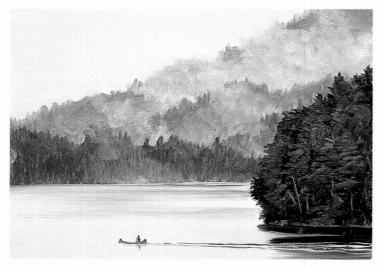

Mist on Upper Saranac Lake

paint early and late. The middle of the day is better for eating and napping. I paint feelings, emotional memories, smells, temperature, and sounds by trying to be consistent, trying to get it all down in one effort. In two hours, the light changes and I get tired. I have to work small and fast. Golf courses, houses, Main Streets, people—all these make good pictures by others, but I turn away from man-made subjects. They are hard, there's too much narrative involved, and although they elicit noises of recognition, for me it feels like a cheap shot. Most of my subjects are not recognizable, although some viewers know the place or the title. I try to garner an emotional response, which I hope is deeper than simple place recognition.

Like many other *plein air* painters, I use only about a dozen colors, a few brushes, a board to paint on, and a foldable easel. I don't sit down—and I try not to think too much. I don't work indoors after the paintings are completed; most of them are not touched again.

Sometimes, I feel myself making a picture that reminds me of someone else, usually someone famous and impossible to imitate, but the comparison and paranoia quickly pass. For me, painting is like meditation. I concentrate so much and am in such a hurry that my mind cannot wander far before being pulled back.

I have a car, and there are roads and maps; most painters I admire traveled by sailboat, carriage, or mule or they walked. They camped out *and* they painted voraciously. Corot went to Italy three or four times and sketched throughout northern France. Bierstadt trekked through California in the 1860s, Church traveled to South America and Jamaica, Gauguin to Tahiti. It is no wonder that Chase simply wandered around the dunes by his house in Shinnecock—and what mileage he got out of that.

When I'm not painting it seems impossible that I can make even a worthwhile mark with a brush, but once I'm in a generous place and I've got paint on my palette, the place or feeling finds its way onto my easel. For this I am grateful.

I'd like to thank my family and Jane's family for putting up with me; Mark Brady and Laura Bennett for providing wonderful exhibitions; Grace Shin for keeping it all together; Eli Wilner and Jeff Hayman for making beautiful frames; Laura Lindgren for her book design and guidance; Angus Wilkie for his perceptive essay; and finally Mark Magowan, my publisher at The Vendome Press, without whom none of this would have been possible.

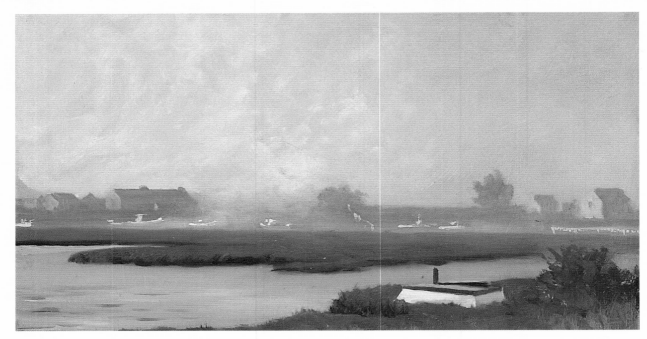

Martha's Vineyard

For Jane, Homer, and Haley

First published in the United States of America in 2005 by Magowan Publishing LLC and The Vendome Press
1334 York Avenue, New York, NY 10021

Copyright © 2005 Magowan Publishing LLC
Paintings © 2005 Simon Parkes
Text (except afterword) © 2005 Angus Wilkie
Photos of Simon Parkes's work by Steven Bates and Ali Elai

Book design by Laura Lindgren

ISBN 0-86565-161-2

FRONT CASE BINDING: *Main Street, Wainscott* JACKET: *Georgica Beach* PAGE 1: *Coast Guard Station, Martha's Vineyard* PAGES 2–3: *Long Lane* PAGES 4–5: *Fallen Tree, East Hampton*

PAGE 8: Gift of Louis P. Church, 1917-4-419. Photo: Scott Hyde PAGE 10: Tate Gallery, London/Art Resource, NY PAGE 11: © The National Gallery, London PAGE 12: Catharine Lorillard Wolfe Collection, Wolfe Fund, 1979. (1979.404) Photograph © 1990 The Metropolitan Museum of Art

Library of Congress Cataloging-in-Publication Data
Parkes, Simon.
 Summer places / by Simon Parkes.
 p. cm.
 Includes bibliographical references.
 ISBN 0-86565-161-2 (hardcover : alk. paper)
 1. Parkes, Simon—Catalogs. 2. Plein air painting—Northeastern states—Catalogs. 3. Northeastern states—In art—Catalogs. I. Title.
 ND237.P252117A4 2005
 759.13—dc22 2004026384

Printed in China